IMAGES
of America

DEDHAM

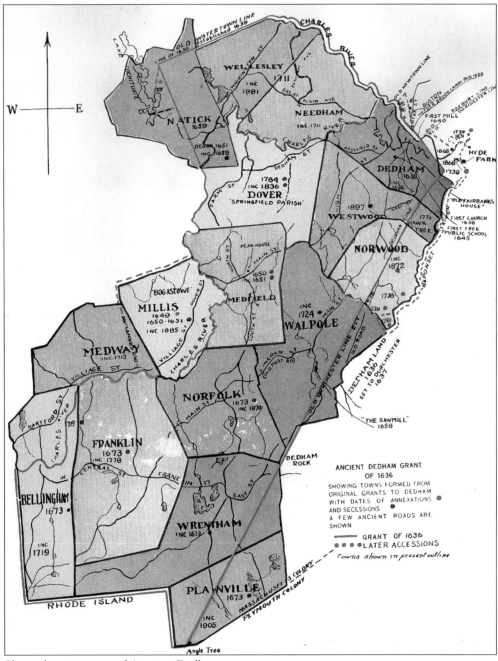

Shown here is a map of Ancient Dedham.

On the cover: Shown in this photograph is the Fairbanks House, the oldest wood-frame house in America, built *c.* 1636, and open to the public as a historic site.

IMAGES
of America

DEDHAM

Dedham Historical Society

ARCADIA

First printed in 2001.

Published by Arcadia Publishing,
an imprint of Tempus Publishing, Inc.
2A Cumberland Street
Charleston, SC 29401

Printed in Great Britain.

Library of Congress Catalog Card Number: applied for.

For all general information contact Arcadia Publishing at:
Telephone 843-853-2070
Fax 843-853-0044
E-Mail sales@arcadiapublishing.com

For customer service and orders:
Toll-Free 1-888-313-2665

Visit us on the internet at http://www.arcadiapublishing.com

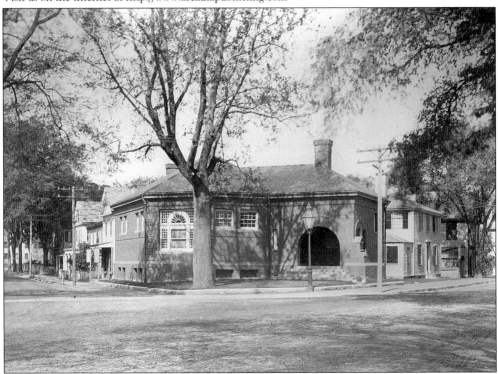

The Dedham Historical Society building, designed by architect Edwin J. Lewis in the Romanesque Revival style, was built in 1887 with a bequest from Hannah Shuttleworth. The Dedham Historical Society was organized in 1859. The society originally had a closet in the Norfolk County Court House, used for archival storage, and held its meetings in the basement. This photograph was taken c. 1890.

CONTENTS

Acknowledgments 6

Introduction 7

1. Town and County 9

2. Churches 25

3. Industry 35

4. Business 45

5. Waterways 57

6. Houses 67

7. Artists and Other Notables 81

8. Transportation 91

9. Benchmark Events 103

10. Service for Country 111

11. Organizations 117

ACKNOWLEDGMENTS

The Dedham Historical Society is most fortunate in having many thousands of photographs, glass plate negatives, and lantern slides. Large numbers, and many used herein, were donated to the Dedam Historical Society by the Dedham Camera Club and professional photographers Jonathan Guild and Robert T. Rafferty; others included are several previously unpublished photographs by the world-famous Fred Holland Day. We are grateful also to many individuals for photographs used that were given in the past and more recently, especially for this book. Credits for loaned photographs are noted with the image.

In order to undertake this publication, a major collaborative effort was made by a team of volunteers who were given extraordinary guidance and total commitment to the project by our volunteer librarian, Margaret L. (Peg) Bradner, assisted by our volunteer photo-archivist, Joan Kelleher Conklin.

While all who have worked on this project considered it "fun," it goes without saying that the process became tedious and frustrating at times, considering the fact that when photographs were given to the Dedham Historical Society over the course of its 143-year history, there was a general assumption that everyone knew who and what were in the photographs, so why bother writing it down, anywhere!

Special thanks to the following who took on sections of this book: "Town and County," Joan Kelleher Conklin; "Churches," Jean Garvey and Peg Bradner; "Industry," Peg Bradner and James D. Kaufman (Dedham Pottery); "Business," Hana Janjigian Heald; "Waterways," Jane A. Breede; "Houses," Andrea Gilmore and Jean Flanagan Gerstenhaber; "Artists and Other Notables," Molly Jackson; "Transportation," Kathleen M. Brown; "Benchmark Events," Sarah Ducas; "Service for Country," Jonathan Cook; "Organizations," Jill H. Shiel and Peg Bradner; and to Kay Bradner for layout.

Thanks also to the Dedham Visionary Access Corporation, which has supported printing and conservation of many glass plate negatives and lantern slides in our collections, and to Robert Brand Hanson, Dedham's unofficial town historian, whose inestimable topical knowledge and review of the following text has helped immeasurably.

—Ronald F. Frazier
Executive Director and CEO
Dedham Historical Society

INTRODUCTION

In September 1635, the Massachusetts General Court ordered settlement of two inland towns to provide the settlements around Boston Bay with relief of population pressures, as well as a buffer against American Indian attack from the interior. The first of those towns was Concord; the second town was Dedham.

From some 200 square miles of land that constituted the original grant to the new town, Dedham subsequently gave birth to the towns of Medfield (1651), Wrentham (1673), Needham (1711), Walpole (1724), Dover (1784), Norwood (1872), and Westwood (1897). Several of those towns later subdivided themselves, ultimately resulting in the creation of 16 towns from Dedham's original territory.

The 14th church of Massachusetts Bay Colony was gathered in Dedham in 1638, selecting John Allin as its pastor and John Hunting as ruling elder. The following year, the town initiated the practice of electing selectmen to carry out the general administration of town affairs. The Dedham Town Meeting was continued in an open-meeting format from the creation of the town until 1927, when the town changed to the representative town meeting structure, which is still observed.

The era of the Revolutionary War produced a number of important figures from the citizens of Dedham, including the Samuel Dexters (father and son), Dr. Nathaniel Ames the younger and his brother Fisher, and the Reverend Jason Haven and his son Samuel. It was to the leadership of these men that the town turned in the first generation of American independence.

In 1793, Dedham was selected as the shire town for the new county of Norfolk, and an influx of lawyers, politicians, and people on county business came to the town. The Norfolk and Bristol Turnpike was constructed through Dedham in 1803, providing a main route between Boston and Providence. One year later, the Hartford and Dedham Turnpike was chartered, serving as a main road through to Connecticut. Many taverns appeared, providing for the wants of the traveler, as well as the relay-station needs of the new stage lines that the turnpike had suddenly made feasible.

In 1835, the Boston and Providence Railroad built a branch from Dedham to Readville, connecting with the main line from Boston to Providence. In 1848, the Norfolk County Railroad provided a link to Walpole and, in 1854, the Boston and New York Central connected Dedham to Blackstone. The resulting availability of quick freight service promoted a burst of industrial development.

Mother Brook, a canal dug from the Charles River to East Brook in 1639, initially provided

a connection to the Neponset River and waterpower to the town's corn mill. In later years, it powered many Dedham industrial enterprises. Factories along that waterway rolled copper for state coinage, made paper, supported a brush factory and a wire factory, and powered numerous textile concerns. Here and elsewhere in town, thread, woolens, silk, brooms, furnaces, shovels, chairs, cabinets, tinware, sheet iron, vehicles, boots, shoes, saddles and harnesses, cigars, pocket notebooks, and marbled paper were produced for regional and national markets.

Even before 1900, the ancient farmlands of Dedham were being subdivided for residential development. At the time of World War I, the town's industrial and commercial base had suffered significant deterioration. The redistribution of population and the economic restructuring that followed World War II put the final nail in the coffin of Dedham's manufacturing sector and reconfigured it into a bedroom community.

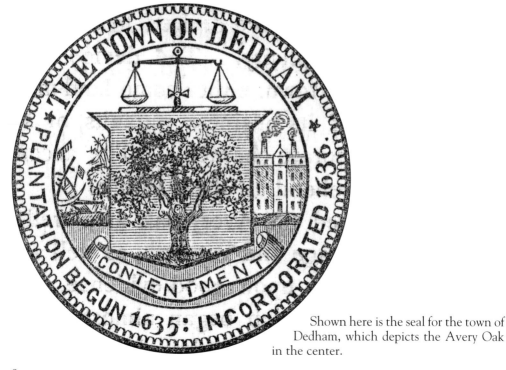

Shown here is the seal for the town of Dedham, which depicts the Avery Oak in the center.

One

TOWN AND COUNTY

Dedham's first U.S. post office was established in April 1795, with Jeremiah Shuttleworth as the postmaster. He kept the Dedham post office in his West India Goods Shop on High Street, at the site of the Dedham Historical Society. Shuttleworth would put the mail on a table; individuals would come into his store and help themselves to their mail. Some 38 years later, Dr. Elisha Thayer succeeded Shuttleworth.

Norfolk County's first courthouse was built in 1796. It had served Norfolk County for about 30 years when, in 1827, it was sold at public auction. It was used as a millinery shop and a dwelling on the lower floor and an assembly room on the second floor. In 1845, it was sold to the Temperance Hall Association. On April 28, 1891, the old courthouse was destroyed by fire.

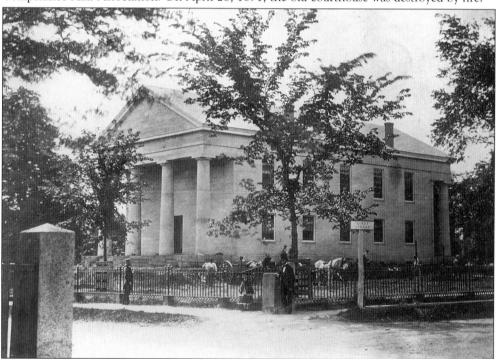

This is an 1860 photograph of the second Norfolk County Court House. It was dedicated on February 20, 1827. Built on High Street, on land bought from the heirs of Fisher Ames, the building was 48 feet by 98 feet, two stories in height, and made of granite with a 10-foot projection at each end resting upon four Doric pillars. The north wing was added in 1861.

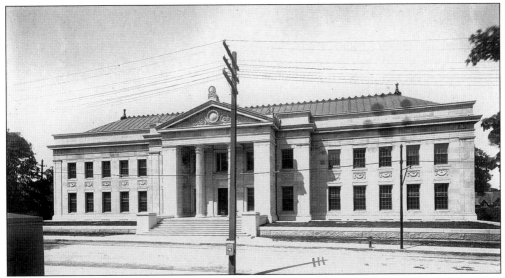

The Norfolk County Registry Building, located on High Street, was built in 1905. The main section of this building is 52 feet by 186 feet, two stories high, and made of Deer Isle granite. It has a projection 68 feet by 80 feet in the rear of Pompeian brick. The main entrance has two Corinthian granite columns extending to the top of the second-story windows. The roof is made of copper.

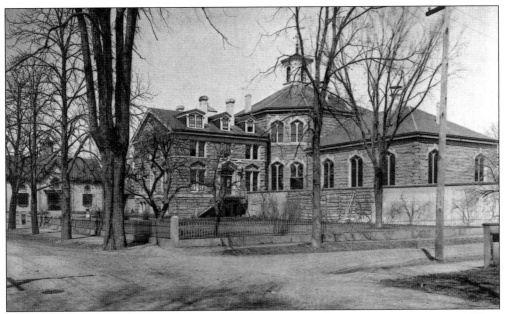

In 1817, Norfolk County built a stone jail, 33 feet square and two stories in height, on Village Avenue. Part of this jail was torn down in 1851 to erect the main portion of the jail pictured here. The octagonal central portion and two wings with cells were added. Inmates were housed here until 1992, when they were transferred to the new jail on the Route 128 median.

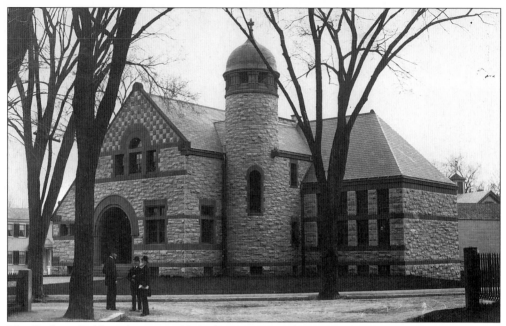

The Dedham Public Library, established in 1872, was located in rented quarters at the corner of Court Street and Norfolk Street. In 1886, the trustees bought land to build a new library on the corner of Church and Norfolk Streets using bequests from Hannah Shuttleworth and John Bullard. The library shown here was constructed of Dedham pink granite and trimmed with red sandstone; it opened in 1888.

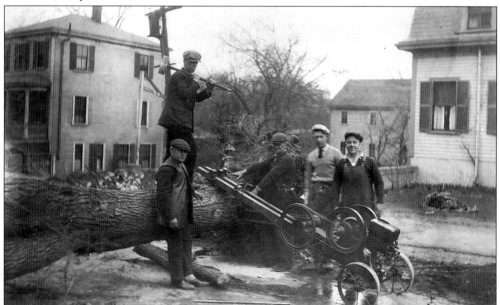

The Dedham Department of Public Works, organized in 1933, was responsible for the maintenance of all the accepted streets, cemeteries, drains, park areas, and tree forestry. This photograph shows a Dedham Department of Public Works crew on High Street during the widening project. From left to right are John Kennedy, three unidentified employees, and Dominic Liberator.

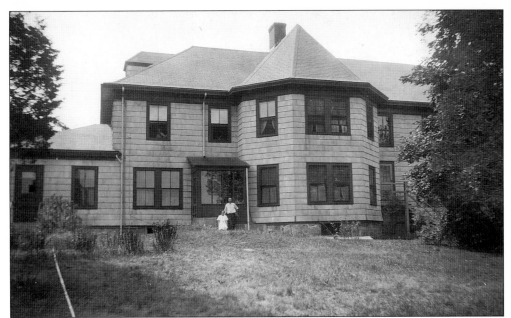

This is a photograph of the Dedham Infirmary, or "Poor Farm," built in 1898. It was located on Elm Street. A two-story addition to the house in 1930 added four double bedrooms, a recreation room, and a bath. A new pantry was built in the kitchen, and the dining room was renovated. The Dedham Infirmary closed in February 1954.

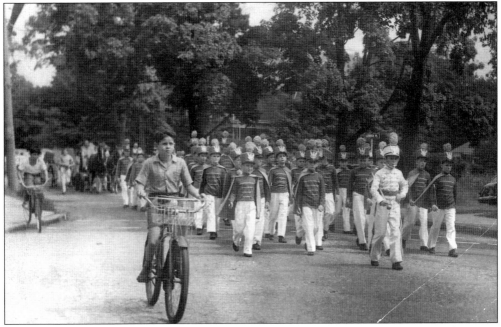

The Dedham Recreation Department began in the 1930s with a group of interested citizens who solicited funds to open and have leadership at three playgrounds. The first Dedham Recreation Commission was elected in 1941. By 1960, there were 10 playgrounds in Dedham. Pictured here is the Opening of Playgrounds Parade in 1941. St. Mary's Fife and Drum Corps is marching along the parade route. (Courtesy of Anthony "Ju Ju" Mucciaccio.)

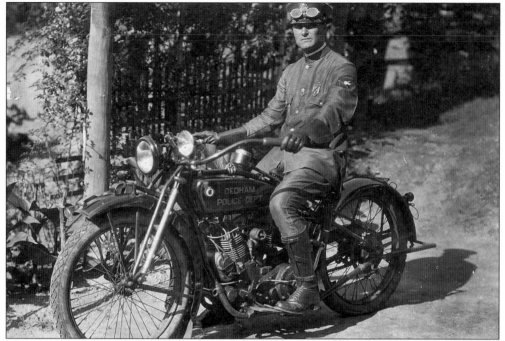

The Dedham Police Department was originally located on the first floor of Memorial Hall. Dedham's first two police officers were appointed in 1876. They were on duty each day from 4 p.m. until 2 a.m. This is a photograph of Albert "Abe" Rafferty, Dedham's first motorcycle officer. Dedham purchased its first motorcycle for the police in 1923.

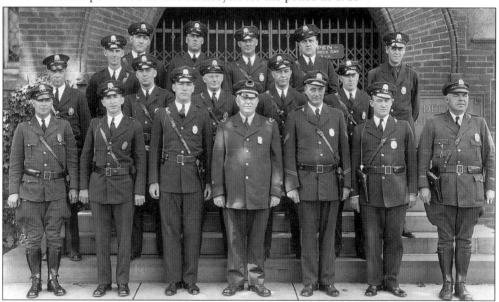

The 1936 Dedham Police Department is pictured here from left to right: (front row) Thomas F. Bready, Leo F. Maida, Nelson LaFreniere, Chief John F. Cahill, Sgt. Albert W. Rafferty, Charles E. McAuliffe, and John J. Keegan; (middle row) John D. Sullivan, Bart McDonough, Harold Connors, Stephen Muirhead, and William P. Kelley; (back row) Raymond F. Lonsdale, William Cummings, Thomas J. Sullivan, Robert E. Greene, Walter H. Carroll, and Laurence C. Carty.

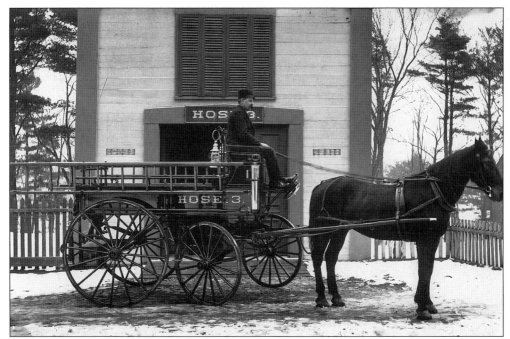

Pictured here is the East Dedham Firehouse, built in 1846. It was located on Milton Street near the old Stone Mill. In 1891, the town bought this hose wagon, Hose No. 3, built by J.V. Fell, J. Wally and Brother, and J. Lynas. This firehouse was used until the Bussey Street firehouse was built in 1897.

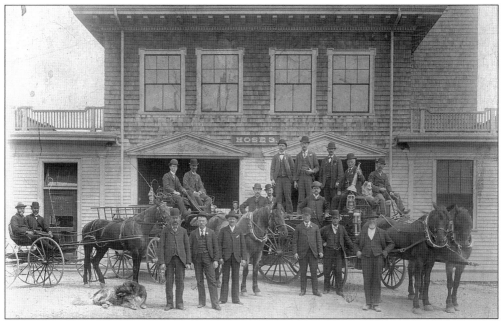

The East Dedham Fire Station on Bussey Street is a wooden structure built in 1897. Located in this firehouse were a supply wagon and Hose No. 3, a horse-drawn carriage that carried 300 feet of hose. There were 12 men in the company in 1897. Dedham firemen did not wear uniforms until 1906.

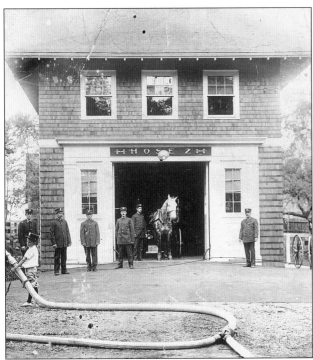

Built in 1908, the Upper Village Fire House was located on Westfield Street. The lower floor contained horse stalls, a stable room, a hose wagon, an engine room, and a rear opening to the paddock. The second story had a company room, a sleeping room, a lavatory, a bath, and a hay and grain room. Horse-drawn streamer engines were housed here. The only fireman identified in this group is Dennis Sullivan, third from left. (Courtesy of Peter Brotman.)

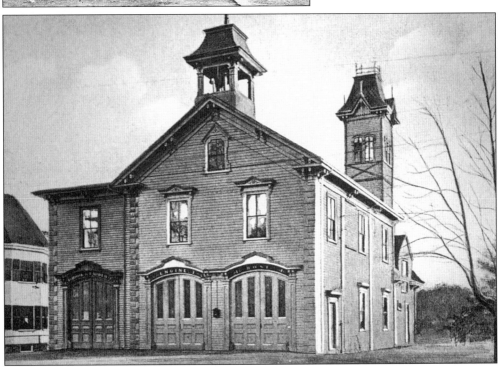

The Central Fire Station was located on the corner of Bryant and Washington Streets. Housed here were the Steamer Engine No.1; Hose No. 1, which was purchased in 1897, could carry 1,000 feet of hose, and was drawn by two horses; and Hook and Ladder No. 1, drawn by two horses. The firehouse had horse stalls and facilities for washing the hose.

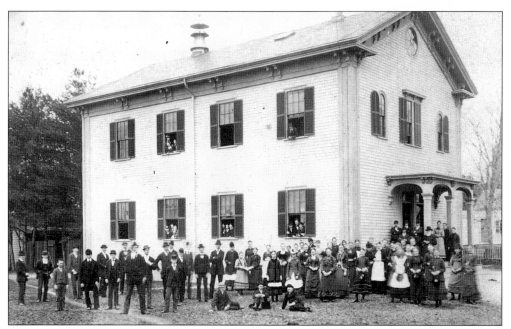

Dedham High School was opened in 1851, with 42 students, in the Masonic Hall on Church Street, over Field's Store. Charles J. Capen was its first master. In 1854, the school moved to the Town House on Bullard Street and, in 1855, moved again to Highland Street, where it remained for 32 years. Pictured here is the Dedham High School on Highland Street.

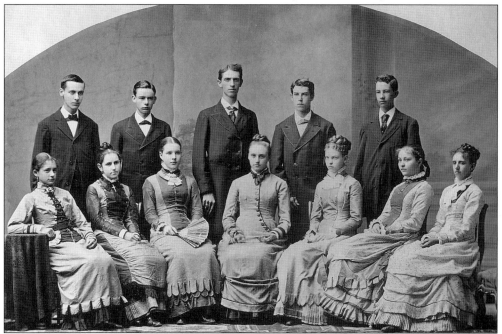

This is a photograph of the Dedham High School graduating class of 1878. From left to right are the following: (front row) Carrie Taft, Helen Page, Sarah B. Baker, Delia Southgate, Addie Gay, Carrie Neal, and Emily Staples; (back row) Oliver Howe, William McQuillen, Robert Southgate, Charles Elmer Russell, and Frank Wakefield.

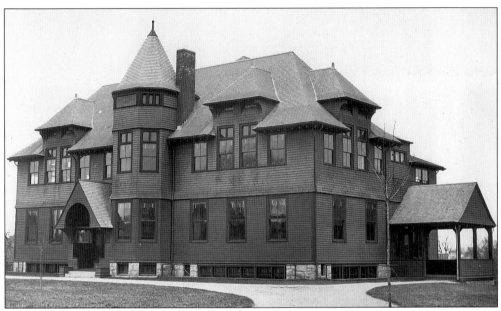

In 1887, a new Dedham High School was built on Bryant Street. The wooden, two-story building was 80 feet long and about 77 feet wide. On the first floor were four classrooms and a study room. On the second floor were a hall and two rooms devoted to chemistry and physics. Later, it became the Ames Junior High School. It was demolished to make way for the present Dedham Town Hall.

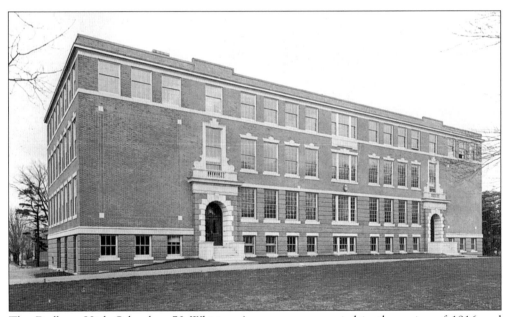

The Dedham High School at 70 Whiting Avenue was occupied in the spring of 1916 and dedicated on March 31, 1917. The building, three stories high with a basement, was constructed of water-struck brick with granite and terra-cotta trimmings. It is currently the Dedham Middle School.

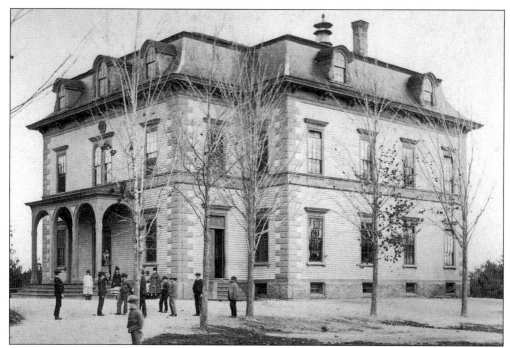

The original Ames School, pictured here, was built in 1859 on Washington Street on the site of the present Ames Schoolhouse Office Center. On each of the first two floors were four classrooms supplied with 50 seats, that number of scholars being deemed sufficient for each teacher. On the third floor was a large hall. The French-roofed schoolhouse was named in honor of Dedham's Revolutionary statesman, Fisher Ames.

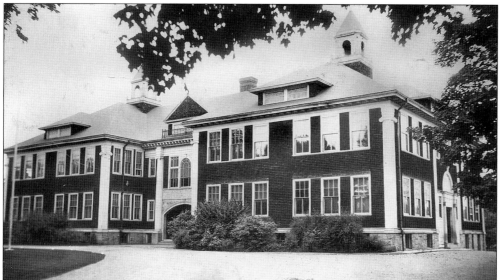

The second Ames Schoolhouse was dedicated in June 1898. On the first floor were the master's room, the teachers' room, and eight classrooms—each 28 feet by 36 feet, capable of accommodating 56 pupils. On the second floor at the southeast end were four classrooms, a chemical laboratory, and the school library. At the northwest end, the main hall was located with a stage and two dressing rooms. It was sold in 1983.

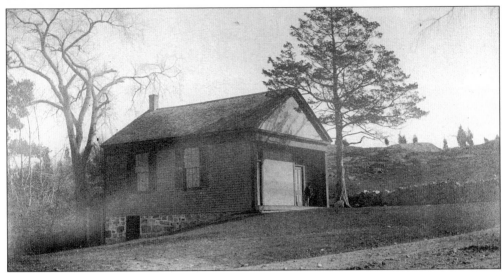

The Burgess Schoolhouse, also known as the Westfield School District and District No. 11, was located on Westfield Street, near the present Schoolmaster Lane. The original schoolhouse was a plain building with red shutters, and inside were plank seats with no backs. A new schoolhouse, pictured here, was built c. 1840. It was named in honor of Rev. Dr. Ebenezer Burgess. It was sold in 1899.

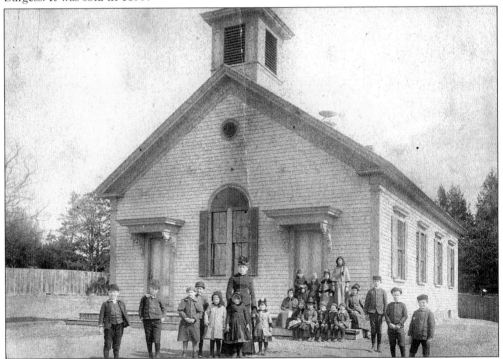

The Endicott School, previously called the East Street School and District No. 5, was located on East Street on the site of the present St. Luke's Lutheran Church. It was named in 1867 after the Honorable John Endicott, a leading citizen of Dedham and, for several years, Dedham's representative in the legislature. Dolly Wales, teacher at the Endicott School from 1887 to 1893, is pictured here with her pupils.

Avery School was named in memory of Dr. William Avery. It was established on May 27, 1784, on Walnut Street. In 1826, a new wooden schoolhouse was built on High Street. This building was replaced in 1844 with the schoolhouse pictured here. A fourth Avery School was built in 1895, which was destroyed by fire in 1921 and replaced with the present brick school.

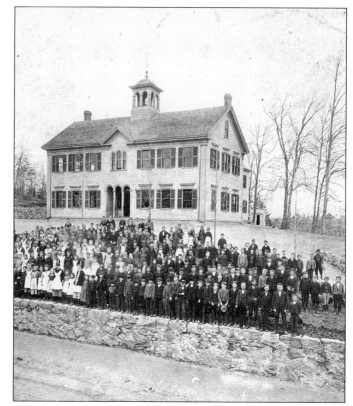

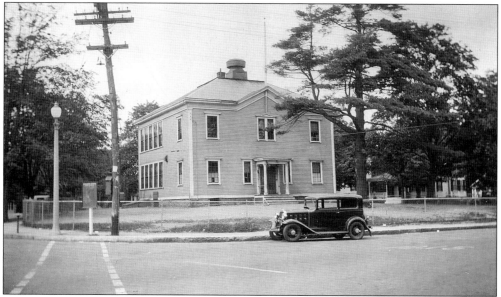

The Oakdale School was established in 1873 in a rented room in the Sanderson Building. In 1878, the first Oakdale schoolhouse, shown here, was built in Oakdale Square. In 1902, a new, brick Oakdale School was built on Cedar Street. The first Oakdale schoolhouse continued to be used at times to reduce overcrowded conditions until c. 1952, when an addition was constructed for the Cedar Street building.

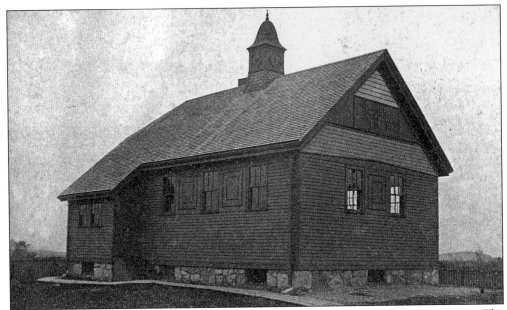

The first Riverdale School was located at the corner of Needham Street and Pine Street. The wooden, one-room schoolhouse had eight windows nearly six feet off the floor. Doors on both sides of the building opened into hallways and cloakrooms with a reception room between them. The school opened in 1885 with 26 pupils and Julia Kennedy as teacher. The present Riverdale School on Needham Street opened in 1922.

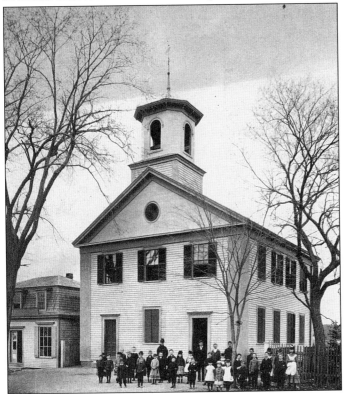

The Dexter School, believed to date back to 1774, was named in honor of Samuel Dexter. The schoolhouse pictured here, located on Dexter Street, was built in 1846 and enlarged and remodeled in 1948. It had four classrooms and a capacity for 100 students. A new Dexter School at 1100 High Street was opened in 1963, but it closed in 1982 and is now leased by the Visiting Nurse Associates.

The Centre School, or Second Middle District School, built in 1822, was located on School Street. It was one story until 1837, when the roof was raised and a second story was added. The building had two classrooms for the primary and intermediate grades on the first floor and one large room with two recitation rooms on the second floor. This building was used until 1858. It is now a private residence.

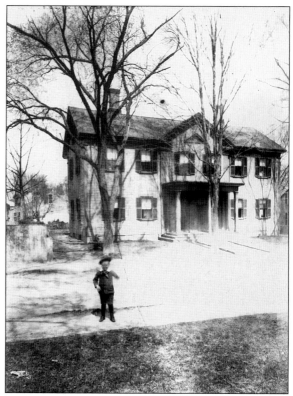

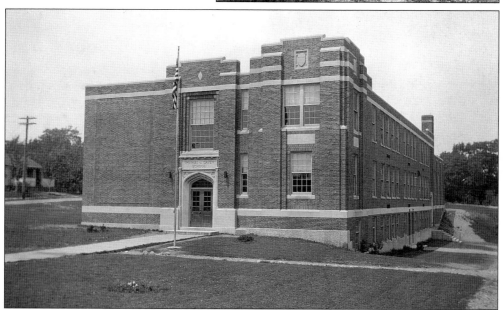

The Capen School, located on Sprague Street, opened in February 1931 and was named in memory of Charles J. Capen, the first principal of Dedham High School. The two-story brick building had 12 classrooms with the auditorium situated at the end of the main floor. The Capen School closed in 1982. It is now the Dr. Thomas J. Curran Early Childhood Education Center, housing a preschool and townwide kindergarten.

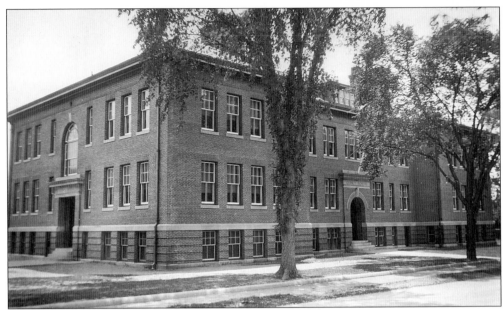

The Quincy School was established in 1873. It was named in honor of Josiah Quincy. On June 4, 1910, the new Quincy School, shown here, was dedicated at the junction of Greenhood, Quincy, and Bussey Streets. This 10-room, two-story school was 140 feet by 79 feet and built of brick with sandstone trimming. It was finished throughout in hard pine. This school was used until 1982.

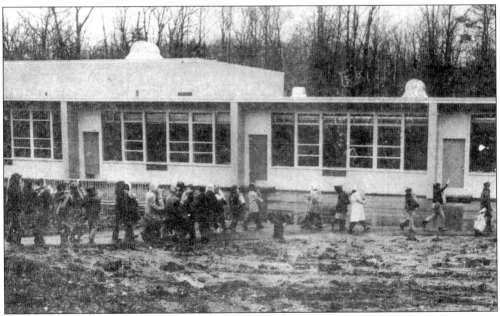

The Greenlodge School on Greenlodge Street opened on January 16, 1956, with 10 classrooms. Mildred Sargent was the first principal of the school. Pictured here are third-grade students carrying their books in paper bags as they made the move from the Capen School to the new Greenlodge School.

Two
CHURCHES

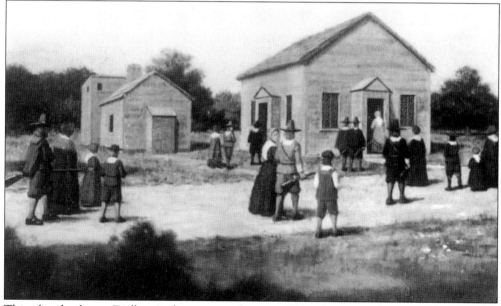

This sketch shows Dedham's first meetinghouse, 1638–1672, on what is now the Little Common. Behind it is the first schoolhouse, built *c.* 1651. The 1645 Dedham Town Meeting pioneered by voting public school funds. John Allin was the first minister, 1639–1671. Under Massachusetts laws, the costs of church and minister were paid by all inhabitants of the town, and all should attend church, although only the "saved" could be elected members.

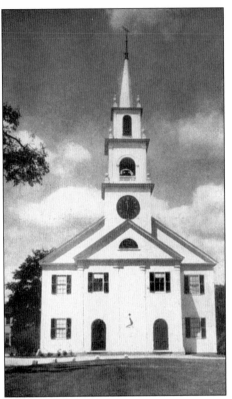

In 1818, when a majority of Dedham parish members voted for Alvan Lamson (a new minister trained under a liberal Unitarian professor of divinity at Harvard), a majority of church members seceded and founded a new Congregational church. This 1763 second meetinghouse, is now the Unitarian church. It was remodeled and realigned after 1820 to face the Little Common. Dr. E.A. Taft took this photograph in 1893.

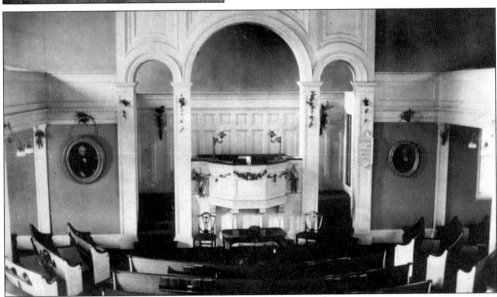

Alden Daniels took this photograph on December 28, 1930, showing the interior of the Unitarian church decorated for Christmas. The two portraits show the Reverend Alvan Lamson (left), "minister after the division," who served to 1860, and the Reverend Joseph Belcher, the third minister, who served 1693–1723. The other early ministers were William Adams, 1673–1685; Samuel Dexter, 1724–1755; Jason Haven, 1755–1803; and Joshua Bates, 1803–1818.

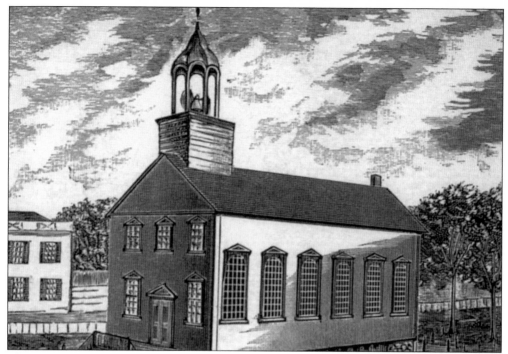

This second Episcopal church, 1798–1845, was located on what is now Franklin Square, a small piece of the 135 acres of land bequeathed to the church by Samuel Colburn, who died in the French and Indian War. The first Episcopal church, a simple 30-by-40-foot building, had been built on Court Street in 1758. Episcopalians suffered controversy too, over Tory leanings of the first minister, Rev. William Clark.

Arthur Gilman of Boston designed the third Episcopal church based on the medieval design of St. Magdalen's College, Oxford, England. This wooden structure at the corner of Court Street and Village Avenue was 90 feet in length with a 100-foot-high tower. Thomas and Nathan Phillips of Dedham were the builders. Interior finishing matched the elegant exterior. The church was consecrated in 1845 but burned in 1856.

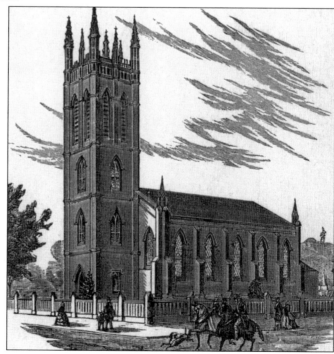

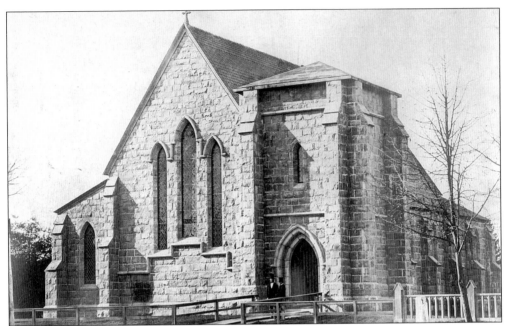

Many church members contributed to raising the fourth St. Paul's. This photograph was probably taken shortly after the church was completed in 1858. The Reverend Samuel B. Babcock was the rector from 1834 to 1873, thus serving in three church buildings. In 1869, the church added the present tower. Ira Cleveland gave the bell. George E. Hutton left a bequest for a chapel, now St. Paul's Nursery School.

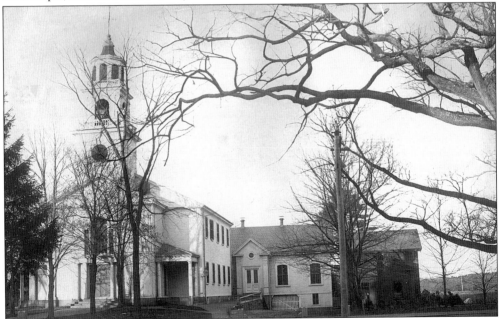

The Orthodox Congregationalists who separated from the First Parish Church built the Allin Congregational Church in 1819 at 683 High Street, the name honoring the Reverend John Allin, Dedham's first minister. The church silver of the early church is on permanent loan to the Museum of Fine Arts, Boston, and replicas were made for the Congregational and Unitarian churches.

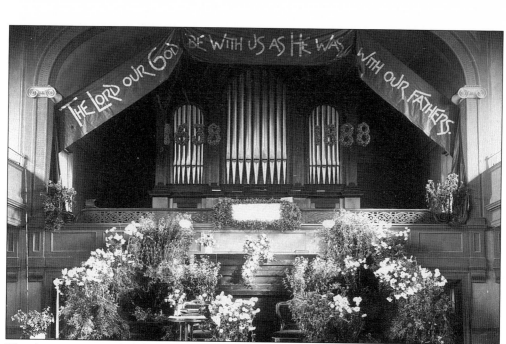

The banner suspended before the organ pipes and the massed flowers in the Allin Congregational Church signals the 250th anniversary of the Dedham church. It was a time of reconciliation. On November 19, 1888, united services were held at the First Parish Church (Unitarian) in the afternoon and the Allin Congregational Church in the evening, with a social reunion between services.

Itinerant preachers held services in private homes for Dedham Methodists as early as 1818. In 1842, Rev. Joseph Pond became the first Methodist pastor. In less than a year, the first Methodist church was dedicated on Milton Street near Walnut Street. There it increased in membership for over 55 years. In 1907, the congregation dedicated this new church at Oakdale and Fairview Streets.

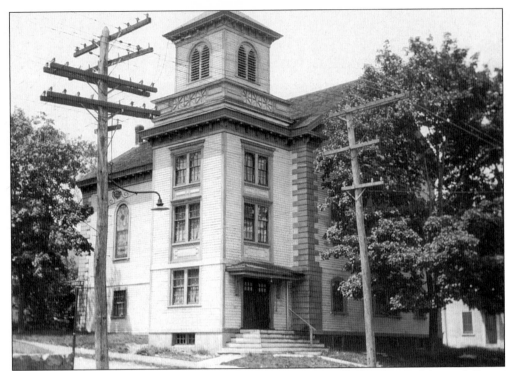

Baptists held meetings in East Dedham in 1822, building a small church near Maverick Street in 1843. They built this church in 1852 at Milton and Myrtle Streets, adding the tower in 1911. The present Baptist church was built on the same site in 1972. In 1994, when the Grace Baptist Church of Roslindale joined the Dedham church, the congregation voted to name their church the Fellowship Bible Church.

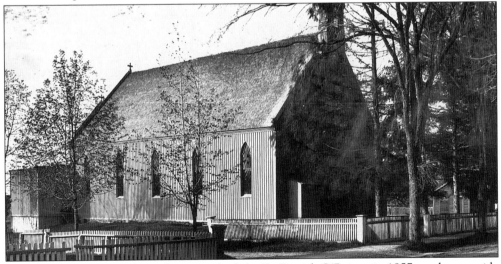

St. Mary's first church, shown here, was built by Fr. Patrick O'Beirne in 1857 on the east side of what was Centre Street, now Washington Street, at present Marion Street. In 1843, the first Mass in Dedham was celebrated at Daniel Slatterly's house, located in Dedham Square, where the Dedham Police Department now stands. Later Father O'Beirne, as a mission priest, celebrated Mass in Temperance Hall.

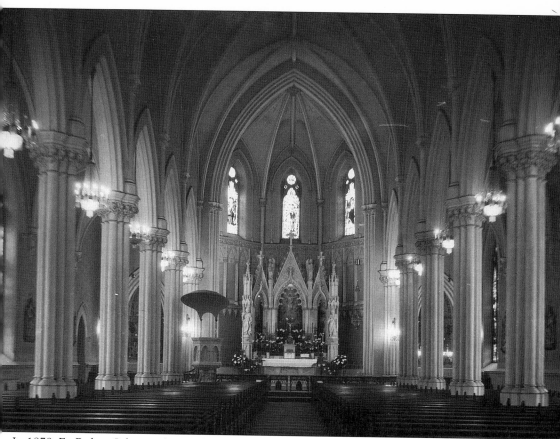

In 1878, Fr. Robert Johnson dreamed of raising "a Cathedral in the Wilderness" for his growing congregation. He established a committee of his parishioners to work for the new church and reached out to community leaders for support. A.W. Nickerson helped with funds. John W. Bullard donated Dedham granite for the church. In 1880, thousands came to Dedham to witness Archbishop John J. Williams lay the cornerstone. At first, Mass was celebrated in the lower church; Rev. John H. Fleming, who came to Dedham in 1890, completed this upper church. Like a cathedral, St. Mary's received light through many stained-glass windows. Columns divided the side aisle from the nave. The ceiling demonstrated lofty Gothic vaulting. A high apse behind the alter and sanctuary had stained-glass windows portraying St. Patrick, St. Peter, the Assumption of the Virgin Mary, St. Paul, and St. Brigid. Behind the alter was a carved screen, the reredos, with statues of St. Peter and of St. Paul standing on each side. Archbishop Williams of Boston dedicated St. Mary's Church on September 9, 1900.

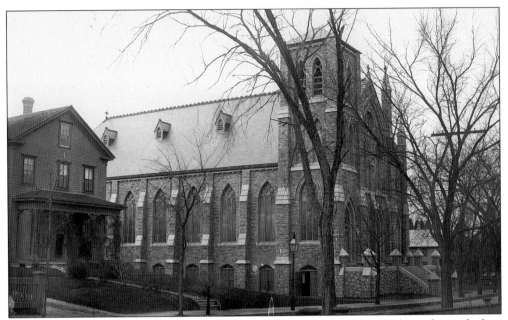

St. Mary's Church on High Street shows the original design of front stairs, later changed when High Street was widened. In 1866, just after St. Mary's became a separate parish, Fr. John P. Brennan purchased the site on High Street to use the house, shown at left, as a rectory. The present rectory was also built of Dedham granite supplied by Alfred Rodman in memory of his daughter, a nun.

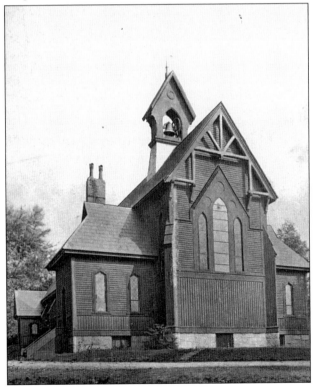

The Church of the Good Shepherd (Episcopal) in Oakdale Square had its roots in 1873 in a Sunday school class and services with lay readers for Oakdale Episcopal families who could not conveniently go to the center of Dedham to St. Paul's Church. Just three years later, the cornerstone was laid for this church, which can be seen here about the time of its dedication in 1876.

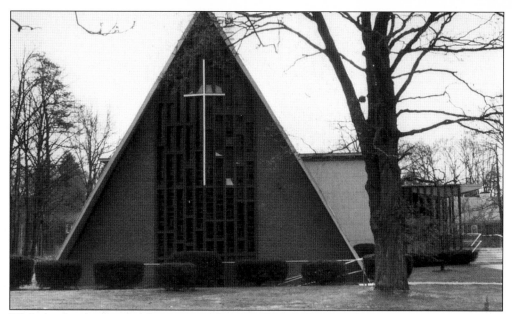

With the development of that section of East Dedham called Germantown, a growing Lutheran population first held services in members' homes. In 1892, St. Luke's Lutheran Church was founded. Two years later, the group bought the chapel owned by the Allin Congregational Church just over the town line in West Roxbury, enlarging the chapel in 1917. St. Luke's built this modern church in 1960 at 950 East Street.

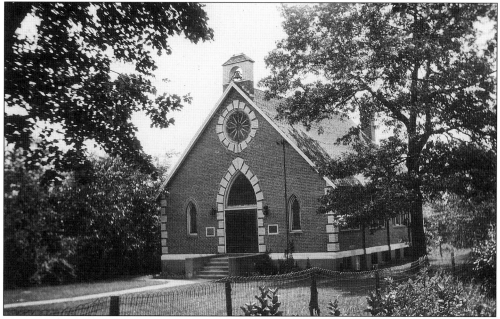

This is the Riverdale Congregational Church in 1914, the year it was dedicated. The Riverdale congregation began from Sunday school classes held at William Lent's boathouse in 1911. Mr. and Mrs. Henry Bingham donated land and funds to build the church. In the 1960s, the congregation built an addition and remodeled the front of the church. It is now the Calvary Baptist Church.

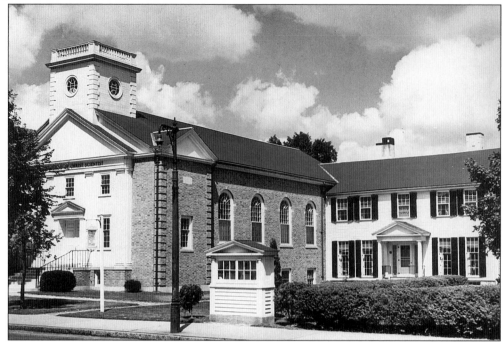

The first Dedham Christian Science Society held services in Odd Fellows Hall in 1920 and later in the Masonic Temple in 1930. In 1932, the society bought the house built in 1772 by Dr. Nathaniel Ames and moved it back on the property to be attached to this new church, shown here in 1940 before the steeple was added. The church cornerstone was laid in December 1938. Services began on March 3, 1940.

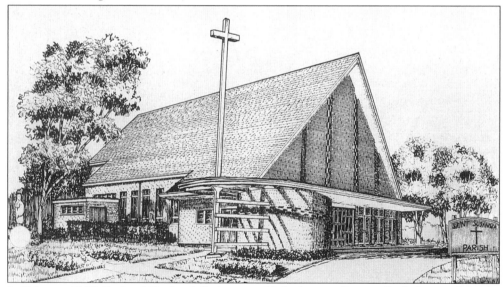

In February 1960, Richard Cardinal Cushing established a new Roman Catholic parish in the Riverdale section of Dedham and named it St. Susanna's after his titular church in Rome. During construction of this church, Fr. Michael Durant, the first pastor, celebrated Mass at Moseley's on the Charles. The first Mass at St. Susanna's Church was celebrated on February 11, 1962.

Three

INDUSTRY

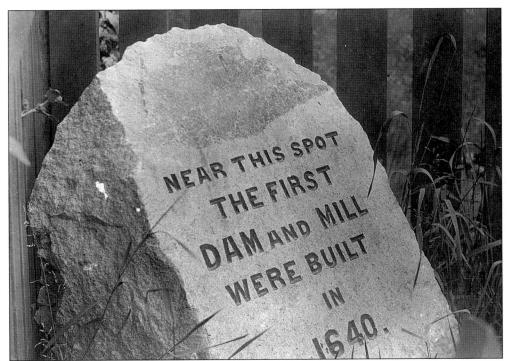

NEAR THIS SPOT
THE FIRST
DAM AND MILL
WERE BUILT
IN
1640.

The first dam on Mother Brook (also called Mill Creek) was near Bussey Street. The 1639 Dedham Town Meeting voted to dig a ditch, diverting water from the Charles River to the headwaters of a brook that dropped steeply east to the Neponset River to provide waterpower not found in the Charles or Neponset, both slow-moving near Dedham. One third of the Charles River flow spills over the sill by the Veterans' Parkway.

The first mill was a corn mill or gristmill operated by the Whiting family for 174 years. Dedham granted privileges to use waterpower at five locations on Mill Creek: the second at Maverick Street, the third at Mill Lane, the fourth beside Milton Street, and the fifth in the present-day Readville section of Hyde Park. Henry Hitchings sketched this typical gristmill in the 19th century.

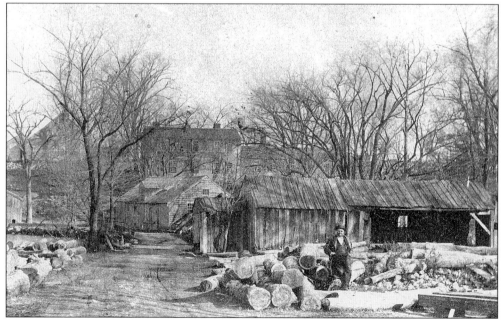

At first, the town voted to provide pits for hand-sawing lumber, set prices for felling trees, and named committees to bring timber to the pits. The first sawmill was located in the part of Ancient Dedham now in the town of Walpole. The sawmill in this 1868 photograph was on the south side of Mill Lane, using waterpower at the third privilege on Mother Brook.

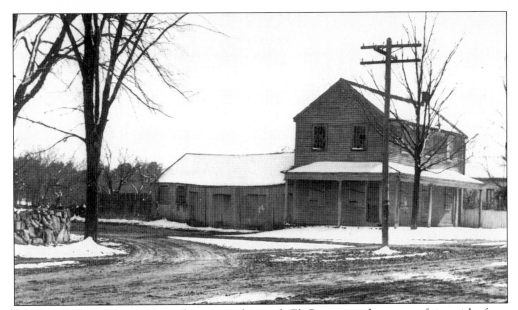

In 1800, Calvin Whiting formed a partnership with Eli Parsons and a group of tinsmiths from Connecticut to build this shop on the corner of High and Lower Streets. They manufactured tinware, which was peddled all over New England. The area became known as Connecticut Corner, attracting more businesses, including an East India Goods, or dry goods store, in the house shown here.

Dedham cotton pickers worked at home to clean and blend the raw cotton fiber on mill machinery lent out by the Norfolk Cotton Company. Local shareholders put up the funds to build a spinning mill in 1808 on Mother Brook at the dam on Maverick Street, the second privilege. After the War of 1812 ended, the mill failed due to high-cost inventory in the face of cheap imports.

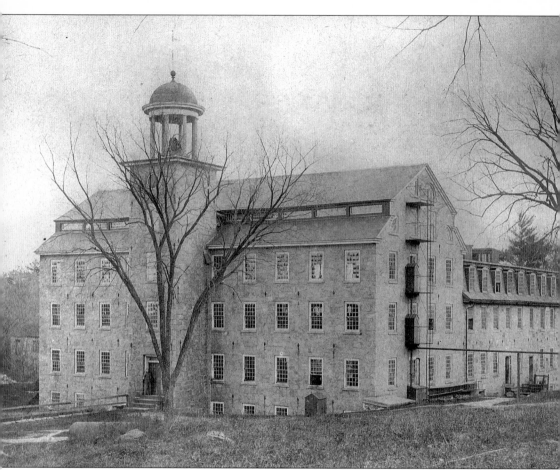

In 1823, a new partnership bought the machinery from the failed cotton mill for a factory at the fourth dam on Mother Brook by Milton Street. Already this fourth waterpower privilege had operated a fulling mill, a copper-cent company, two paper companies, a wire mill, and a nail factory. The new company, the Norfolk Manufacturing Company, prospered under the leadership of an experienced cotton manufacturer, Frederick A. Taft. In 1835, he built the initial section of this stone mill of Dedham granite. Thomas Barrows bought the mill in 1863 to produce woolen goods. The factory became part of the holdings of other major woolen manufacturers in later years. In the early 19th century, J. Eugene Cochrane made carpets in this building and others at this site. The final industry here was the United Waste Company, a textile-recycling company. The Stone Mill is now the center of the Mother Brook Condominium complex.

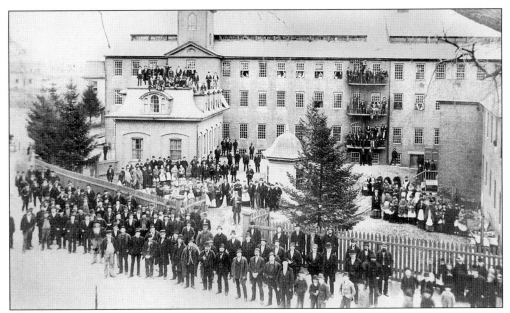

This work force stands *c*. 1880 at the Bussey Street mill. After the Revolution, Benjamin Bussey was a successful silversmith, selling spoons and spurs for a decade at the shop in his home on East Street. He bought the Maverick Street site in 1819 and this site in 1824 to produce woolen goods. He first brought Thomas Barrows to Dedham as superintendent and George H. Kuhn as treasurer and agent of the company.

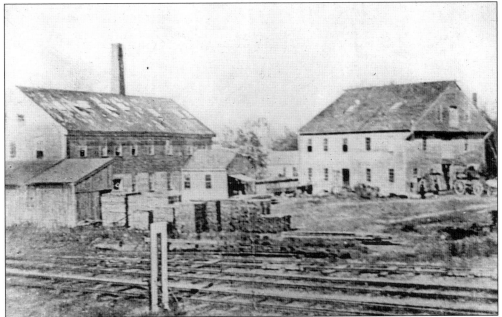

The Russell and Baker furniture company was founded in 1833 at Connecticut Corner, where it grew to 500 workers. After two bad fires, it moved downtown in 1853. A neighbor, Arthur Thayer, wrote his memories of these buildings on the curve of High Street. He remembered workers at the machines in shops, especially "Brad" Calder and others carving fruits and flowers on the fine black walnut pieces.

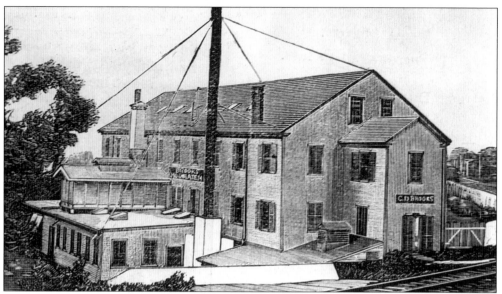

This building, located on Eastern Avenue, is near the site of the old silk factory built in 1836. Jonathan H. Cobb, superintendent, advertised, "A few girls may find employment at winding silk." Also, he had "18,000 Mulberry Trees for sale." Silk was briefly profitable. Later industries here included a dye house, a laundry, and a playing card company, preceding the C.D. Brooks Chocolate Factory, pictured here *c.* 1880.

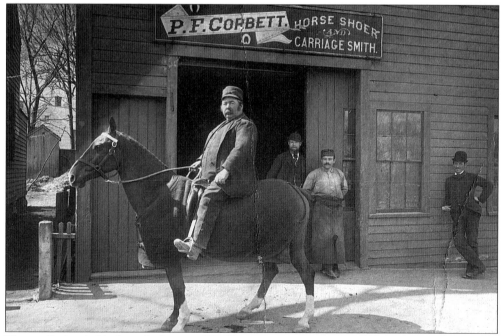

This is Corbett's blacksmith shop on Washington Street, near High Street. Blacksmiths, the first mechanics in Dedham, furnished tools at public expense. The 1903 Dedham directory lists three blacksmiths on High Street, three on Washington Street, and one each on Church, Whiting, and Worthington Streets. The 1941 directory was the last to list a blacksmith, Frank P. Kern on Williams Street.

Hugh C. Robertson (1845–1908) was the son of James Robertson, a fourth-generation master potter who brought his family to the United States from Scotland in 1853. Robertson worked with two brothers and his father in a small art-pottery business in Chelsea, Massachusetts, from 1868 until the 1890s. Eventually, while working alone at the Chelsea Keramic Art Works Pottery, Hugh C. Robertson became world renowned in art-ceramic circles in the 1880s for his stunning achievement of a blood-red glaze on his hand-thrown stoneware vases. The enormously high production cost of those red vases threw Robertson's business into bankruptcy, even while his work was enjoying great critical acclaim. Wealthy Boston art patrons financially rescued Robertson *c.* 1892. He then began to employ his other great achievement won during his years of glaze experiments, a consistent crackle glaze applied to a line of tableware with whimsical cobalt blue border designs. In 1896, Robertson moved his pottery to Dedham, and the company and its products were then renamed Dedham Pottery. This photograph was taken *c.* 1875. (Courtesy of James D. Kaufman.)

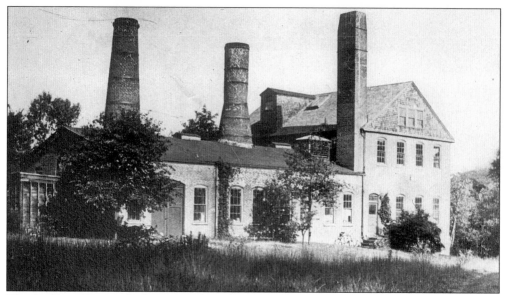

This Dedham Pottery facility opened in 1896. The architect was Dedham Pottery Company board of directors member A.W. Longfellow, nephew of the famous poet. This building served as the location of the Dedham Pottery until it closed for business in 1943. It stood on Pottery Lane just off High Street, near the intersection with Maverick Street and rarely, if ever, employed more than six people at one time. The building burned in the 1970s.

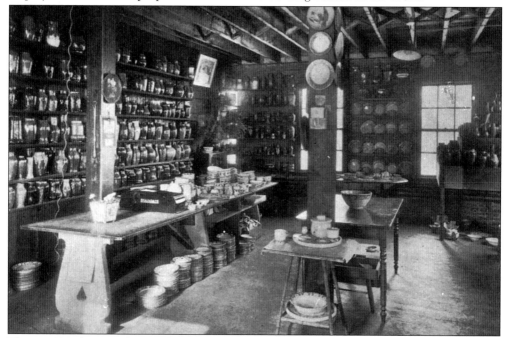

This c. 1933 photograph provides a partial view of the second floor "showroom" of the Dedham Pottery. The production of the Dedham Pottery at that moment in time was just a line of cobalt-blue-decorated, crackle-glazed dinnerware. Please note, however, that the shelves are lined with hand-thrown non-crackle-glazed vases made prior to 1908, when Hugh C. Robertson passed away.

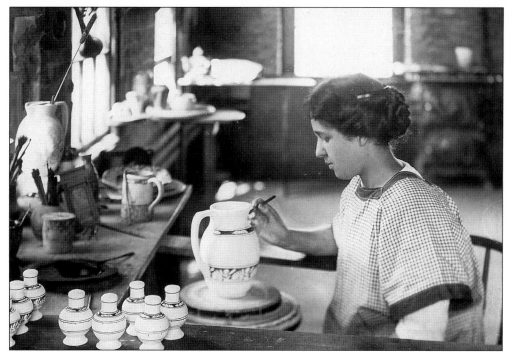

Maude R. Davenport (1884–1956) worked as a decorator at the Dedham Pottery from 1904 until 1928. She signed her pieces with a small circle hidden in the border designs of Dedhamware pieces. Her brushwork was quite skilled, and she is regarded as the Dedham Pottery's most accomplished decorator. She was raised on Greenlodge Street in Dedham. This photograph was taken *c.* 1913. (Courtesy of James D. Kaufman.)

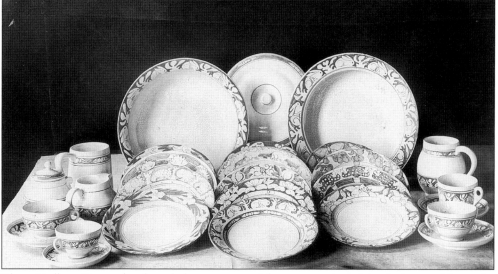

These Dedham Pottery bowls and plates are a partial representation of the designs and forms the company was producing in 1913. All of the pottery was decorated under the glaze in cobalt blue and covered with an intentional gray-white crackle glaze. Dedham Pottery was retailed by Tiffany & Company in New York in the 1890s and was the object of collectors long before its production ceased in 1943. This photograph was taken *c.* 1913. (Courtesy of James D. Kaufman.)

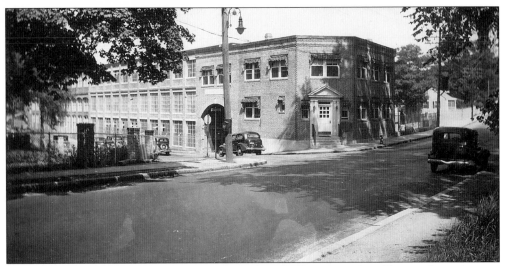

In 1935, the Boston Envelope Company moved to the factory at the old second privilege on Maverick Street. The building still stands, an example of old Mother Brook brick mills, though the waterpower raceway is only impressive at times of floods. Many will remember the Boston Envelope billboard on the Providence Highway and Envelope Park at the corner of Maverick and High Streets, to the left in this photograph.

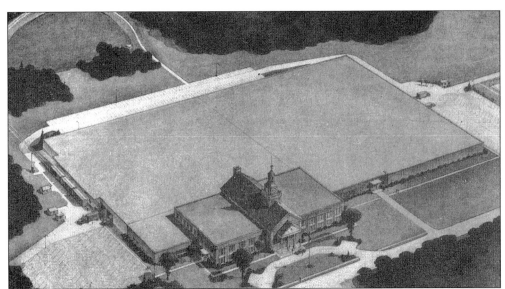

In 1958, the Rust Craft Company built the largest single-story greeting card plant in the world, on what is now Rustcraft Road. The founder, Fred Winslow Rust, had been the first to sell cards with a fitted envelope. The company introduced cards for Valentine's Day, Easter, Thanksgiving, St. Patrick's Day, anniversaries, and travel. Since 1980, the plant has been home to a variety of enterprises.

Four

BUSINESS

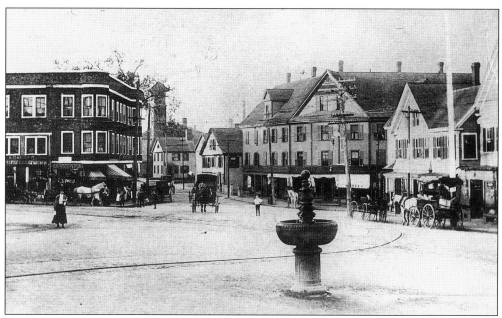

In 1920, East Dedham's Boyden Square (later Hartnett Square) had everything the neighborhood needed: grocery, bakery, apothecary, haberdashery, hardware store, furniture store, stables, lumberyard, newsstand, shoe store, insurance agency, dentist, lawyer, barber, carpenter, plumber, photographer, blacksmith, and undertaker. Trolley tracks bisected High and Bussey Streets, and East Dedham Fire Station's 75-foot tower stood sentinel. In 1961, urban renewal replaced this area with low-cost housing, mini malls, and parking.

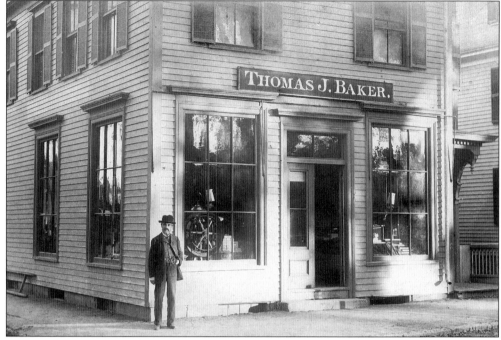

George Alden founded this grocery store at the corner of Court and Norfolk Streets in the early 1800s. Benjamin Adams bought it from him in 1850. Partners George H. Mann and Thomas Baker became the owners in 1865. Baker was joined by his sons Frederick and Edward in 1877, and the business continued in the Baker name until 1926. The building, beautifully preserved, still exists.

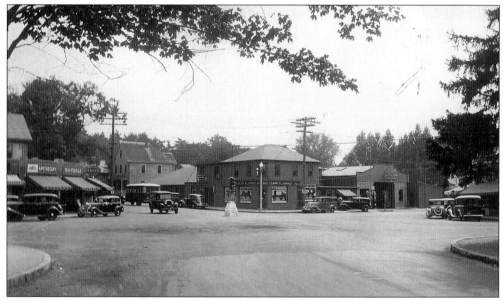

Before 1870, Oakdale was largely woodland. Charles C. Sanderson bought the land and built Sanderson Hall, a large building containing a grocery store. On the second floor was a large auditorium. In 1925, a pharmacy was established on the far corner of the intersection of Cedar Street and Oakdale Ave. Oakdale Square was dedicated as Daniel R. Beckford Square in 1936.

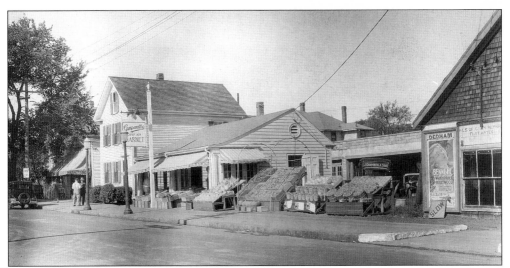

Campanella's Open Air Market opened in June 1927 on High Street, right before the Route 1 overpass. Robert T. Rafferty took this photograph in 1932. Other fruit and vegetable markets in the 1930s directory were Edgerly's on Whiting Avenue, Hartnett's on Mount Hope Street, Johnson's on Myrtle Street, Karafatias' on Washington Street, the Paspates' on East Street, and Siikotos on Emmett Avenue.

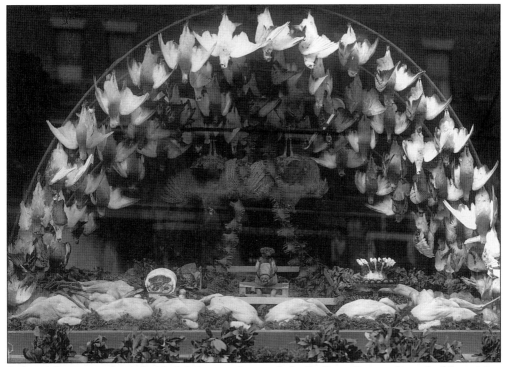

Before refrigeration, households did their marketing daily. Dedham Square always had "provision dealers" to serve them. Baker's (Court Street), J. Everett Smith (Washington Street), Snow Brothers (High Street) and Hamilton's (which delivered by horse cart until after World War II) were popular. This Christmas display in the window of the Union Market (High Street at Eastern Avenue) featured unplucked fowl and suckling pig. Can you spot the teddy bear?

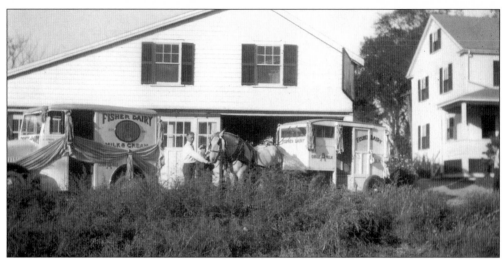

Fisher Dairy, founded by J.L. Fisher in West Dedham in 1861, first sold milk just as it was taken from the cows. In those days, a glass of cooled raw milk or warm milk fresh from the cow was considered to be one of the finest beverages possible. Fisher milk was delivered daily to Boston and all over Dedham by horse and wagon.

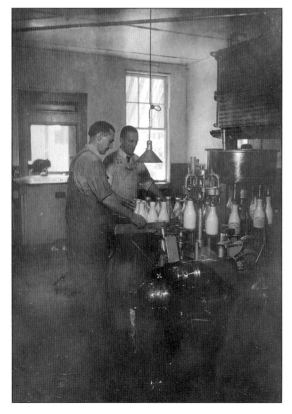

In 1890, J.E. Fisher, the founder's son, built a home on Village Avenue and moved the business there. Later, the dairy was relocated to 51 East Street, where it celebrated its 75th anniversary in 1936. The milk was pasteurized and bottled, capped and refrigerated, and ready for delivery in one of the dairy's route trucks.

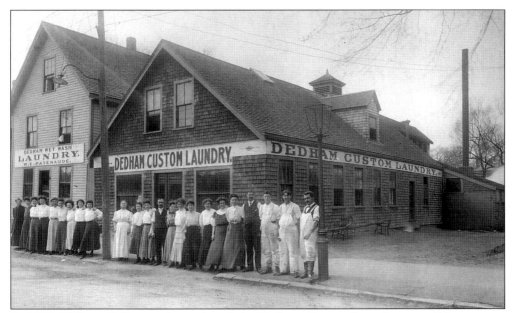

In 1899, William E. Patenaude purchased the Dedham Custom Laundry, a small business on Washington Street, and built it up to a thriving enterprise with 22 pickup and delivery trucks. In 1913, a new plant was built on Mother Brook. When Patenaude died in 1923, two young men took over the business but failed. Patenaude's widow, Bertha, stepped in and managed it herself, winning back most of the lost customers.

Bertha A. Patenaude (front row, third from left) built up the Dedham Custom Laundry until it was the largest one between Boston and Providence. She oversaw Dedham's largest grocery, the Union Market, and looked after 10 other real estate holdings, driving herself from one place to another in her high-powered automobile. Success in business, particularly where men failed, earned her the title of "self-made woman," as the *Dedham Transcript* wrote in 1928.

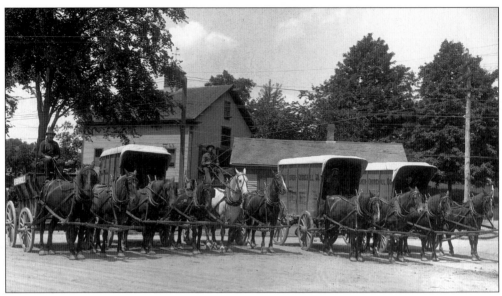

Amory Fisher kept the people cool in summer and warm in winter by selling ice and coal from his business on Church Street. Later, he consolidated with C.C. Churchill, forming the Fisher-Churchill Company, dealing in ice, coal, brick, lime, and cement. The Fisher-Churchill delivery wagons are shown here at the company's yard, at the corner of High and Harvard Streets. With the availability of electric refrigeration in the 1930s, the ice business began to disappear.

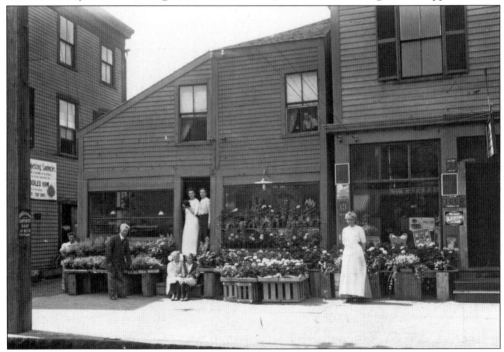

The 1902 directory listed six florists in Dedham. One was Elmer P. Morse, formerly connected with the Botanical Department of Harvard College. He conducted his business and greenhouses for almost 50 years. In the early 1900s, flowers were taken to Boston from Dedham on the train, to be delivered to Boston hospitals.

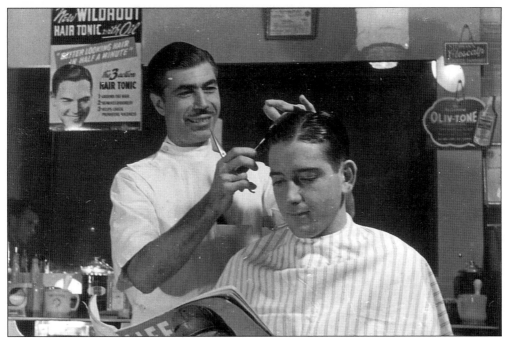

When Domenic Sergi immigrated from Italy, he was 17 but was already a trained barber. He opened his first shop above the Community Theatre on High Street in 1939. Here, he is cutting the hair of Frank Hunt, owner-publisher of the *Dedham Citizen* newspaper (1938–1951). The shop later moved to 595 High Street, in the Knights of Columbus building, where Sergi's son Joe and grandson, Michael, have followed him into the business.

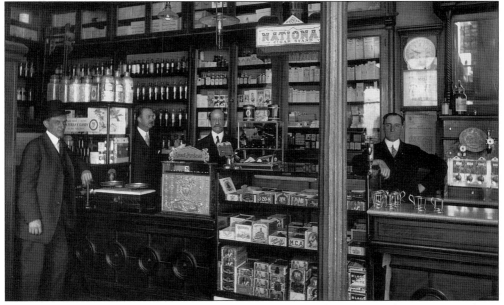

The drugstore at High and Washington Streets was established in 1853 by Henry Smith. In 1882, Henry L. Wardle purchased the business. He specialized in patent medicines, tobacco products, and candy. Young Dedhamites especially loved the soda fountain. Competitors in the square were Hurley's Drug Store and Coles.

51

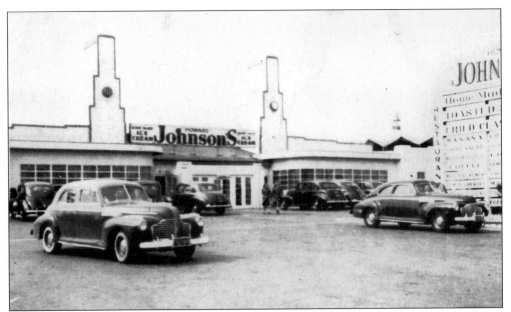

In 1935, Howard Johnson's opened this roadside restaurant, photographed by Joseph Araby, at the present intersection of Routes 1 and 128. Bestsellers were the fried clams and the frankfurters, beans, and brown bread special plate. Howard Johnson's advertised its ice cream as "New England's Best." Cones had a scoop that was pyramidal, with a flat top. A box of Howard Johnson's saltwater taffy made the perfect hostess gift.

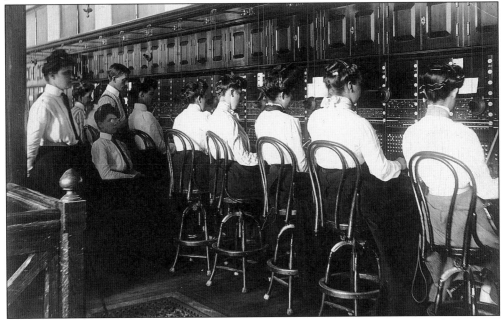

Although it had been invented in 1876, it was not until 1884 that the first telephone in Dedham was installed by Dr. A.H. Hodgdon, in his office at the corner of Franklin Square and Church Street. In 1893, the New England Telephone and Telegraph Company constructed a central office building on Church Street next to the library. Operators worked the switchboard there until 1957, when dial service replaced them.

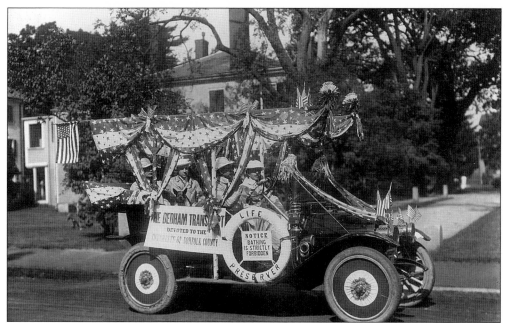

In 1796, the *Columbia Minerva* appeared, Dedham's first newspaper. In 1805, it accepted "all kinds of mercantile produce: good paper, rags, well-cleaned and dried, and green sheepskins for binding" for subscriptions. The four-page, hand-printed *Dedham Transcript* newspaper made its bow in 1870. In 1936, it occupied the second story of the Knights of Columbus building in Dedham Square and participated in the 300th anniversary parade with this float.

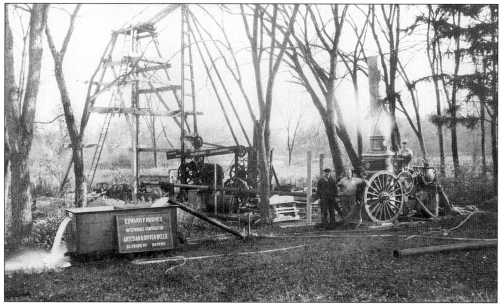

The Dedham Water Company was incorporated by the state in 1876 and authorized to take water from the Charles River. In 1881, the company built the pumping station on Bridge Street and began installing pipelines and fire hydrants to supply the town. This photograph shows a well being dug in the early 1900s near the pumping station. Although in close proximity to the river, the well draws groundwater, not river water.

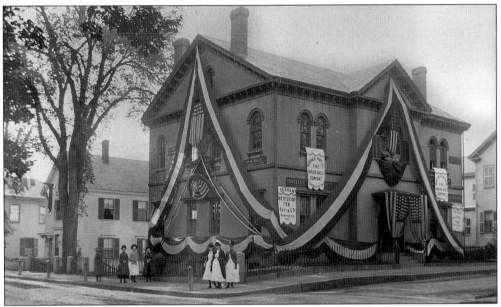

In the early 1800s, house and barn fires were fought by bucket brigades. Every fire threatened destruction of a large area. To protect their assets from various perils, a group of citizens from Dedham and surrounding towns established the Norfolk Mutual Fire Insurance Company in 1825. The company erected this office building at 4 Pearl Street in 1846. Some 40 years later, they joined the celebration of Dedham's 250th birthday.

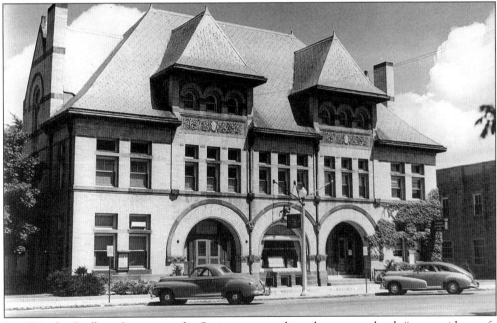

In 1831, the Dedham Institution for Savings received its charter as a bank "to provide a safe and profitable mode of enabling industrious persons of all descriptions to invest such part of their earnings as they can conveniently spare." In 1847, the bank moved into the Norfolk Mutual Fire Insurance Company's building on the corner of High and Pearl Streets and then, in 1891, built its own impressive brick edifice on High Street.

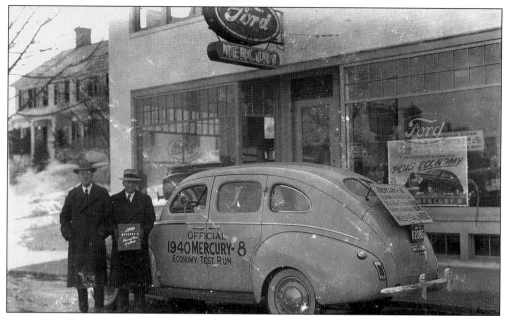

In 1940, Howard Bonnemont and Don Gleason Hill stand in front of Bonnemont's Ford-Mercury dealership on High Street in East Dedham in this photograph by Robert T. Rafferty. The 1939 Dedham directory listed automobile service stations, stores selling automobile accessories and supplies, car repair shops, and garages. There were also businesses that financed the purchase of cars and sold insurance for them.

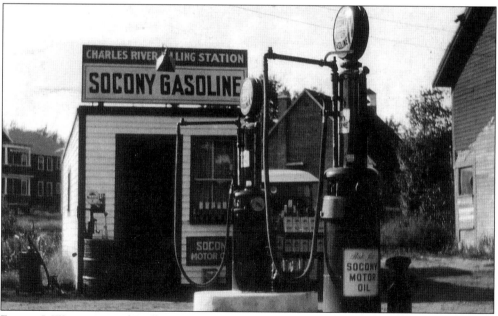

Everett J. Winn operated Dedham's first gasoline pump at his plumbing business at Washington and Richards Streets. He allowed the public to "fill 'er up" on the honor system—leave payments in a box. This photograph shows the town's second filling station, which was on Bridge Street in Riverdale, where Margaret Conley, a widow, installed one on her land to help pay her property taxes. (Courtesy of Mrs. D. Aldous Claffey.)

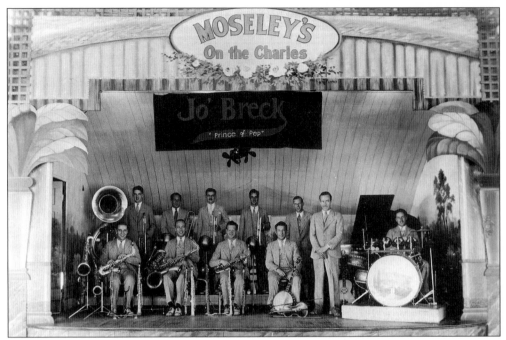

Moseley's on the Charles was erected in 1905, on Bridge Street in Riverdale. A survivor among a long list of contemporary dance halls, it has provided over nine decades of enjoyment for the big band lovers of the 1920s, the swing-era aficionados, and the ballroom dancers of today. As the largest hall in town, Moseley's has also become a popular location for local functions. Legend has it Josiah Moseley built it for his daughter, so she and her young friends would have a place to go in the evenings after a day of boating on the Charles or swimming at nearby Havey Beach. She died before it was built, and it broke Josiah's heart to see the young couples dancing. He sold it shortly after it opened. (Courtesy of Edward DeVincenzo.)

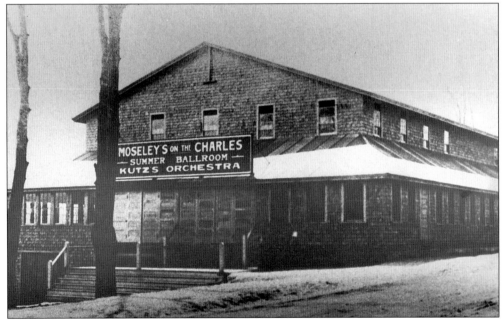

Five
WATERWAYS

Early Dedham settlers made use of this valuable waterway, the Charles River, for transportation. The rivers as well as brooks and ponds provided fish. Open marshland provided grass without the labor of clearing trees. Firewood could be cut in swamp woodlots. A troublesome area was named Purgatory Swamp, as it was the home of wolves, wildcats, and rattlesnakes.

The Causeway Bridge (Needham Street), replaced in 1928, spans the beginning of Long Ditch at the Charles. The half-mile ditch was dug in 1654 across a three-mile loop in the Charles in order to alleviate flooding and improve meadow grassland. It made a part of Dedham into an island now known as Riverdale.

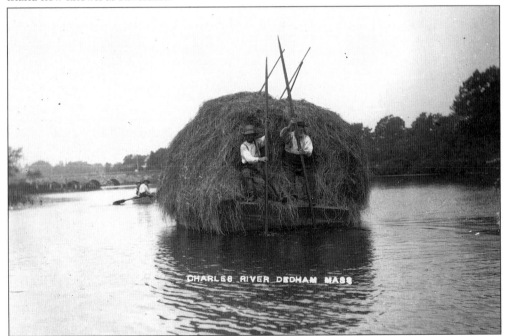

This hay barge shows another practical use of the Charles River. Most early settlers were farmers; even ministers had their own farmland. The early records of the Town of Dedham document land grants for house lots, swamp lots, meadow lots, and upland lots. The records also provided fines for stealing canoes and ruled that all waters in the town were free for fishing.

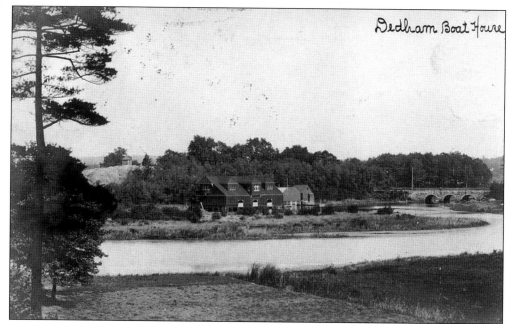

This Ames Street Bridge was built in 1843 and widened in 1926. The photograph shows the second Dedham Boat Club, built in 1883. The club incorporated in 1874 and saw its first building burn in 1882, when struck by lightning. The club's boathouse was enlarged in 1902. It was finally demolished after the club was liquidated in 1934. On the hill is the old Powder House.

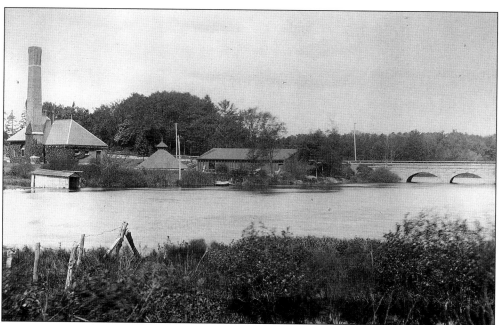

In 1644, Michael Bacon was granted a 10-acre island lot, a parcel of meadow and a parcel of upland beside it, in exchange for some of his land used for a road to the Cart Bridge. The bridge was replaced in 1764 and again (in stone) in 1861. In this photograph, the stone bridge is shown with the pumping station, built by the Dedham Water Company in 1887 and still in operation.

This Mother Brook dam demonstrates the height of water used to turn mill wheels, powering grindstones, saws, spindles, and all manner of industry to support and supplement early Dedham's farming economy. The power of such a dam can still be seen at the Mother Brook Condominiums near the old Stone Mill building on Milton Street.

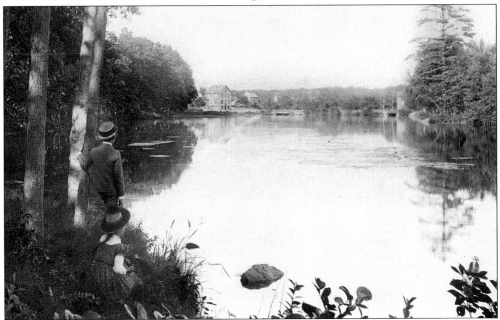

Mother Brook's Middle Mill Pond is shown in this 1893 photograph. It stretches from Maverick Street to Bussey Street in East Dedham. The diversion of water from the Charles River to power the mills caused trouble with Charles River mill owners. In 1831, an agreement between multiple organizations of mill proprietors fixed the water to be diverted by Mother Brook as a third of the flow of the Charles.

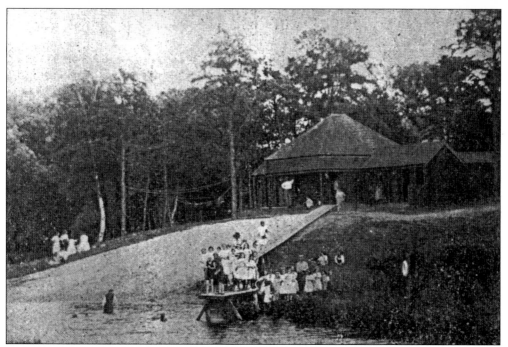

By the late 1800s, Mother Brook beach was a great place for swimming. A new bathhouse was turned over to the Dedham Park Commission on July 28, 1898. This was still an active area in 1937. Eventually, Mother Brook was piped underground in the area of the Dedham mall. At the north entrance to the mall, Mother Brook can be seen running beside Pizzeria Uno.

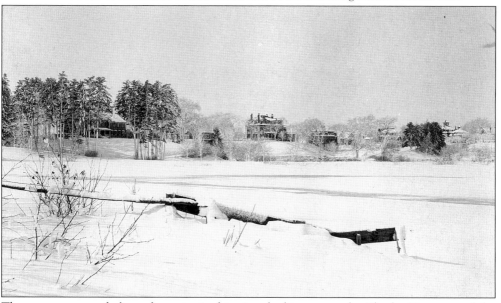

The snow creates a feeling of serenity in this view, looking across the Charles River toward the rear of the houses along High Street. Before the snow, this could have been a starting point for a long skate upriver. Albert Hale, in his reminiscences of Dedham in the 1870s and 1880s, wrote, "River skating was one of the greatest of all winter pastimes. The youth then gathered on the ice must have numbered in the hundreds."

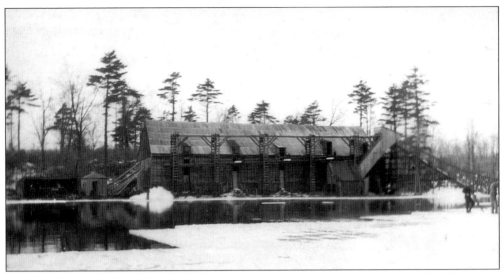

Off Lowder Street on Rodman's Pond was this huge icehouse, photographed in 1924. Before gas or electricity was used for refrigeration, the cutting, storing, and delivering of ice was an important business. Ice was even shipped from Dedham to India. The Charles River's Cow Island Pond and the Wigwam Pond also provided ice for local businesses such as the Fisher Coal and Ice Company. (Courtesy of Dennis Sullivan's grandchildren.)

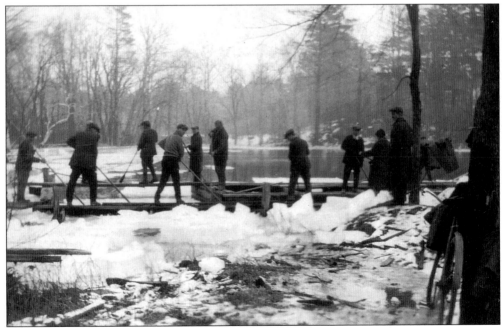

Here are ice cutters at work on Rodman's Pond. Local papers monitored the thickness of ice and reported when the cutting started at six inches or more. Great oblong blocks were scribed on the surface for the men to cut down the lines with huge saws. Here, the men appear to be pushing the cut blocks toward the icehouse ramp. (Courtesy of Dennis Sullivan's grandchildren.)

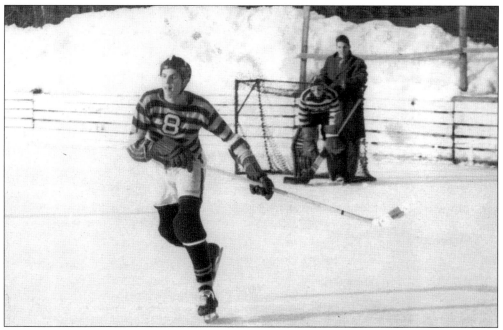

Bill Bliss, a member of the 1948 Noble & Greenough hockey team, takes off. When the Charles River's Motley Pond formed black ice or the ice cover was at least three inches thick, the hockey squad would set up a rink. Until snowblowers started being used in the late 1940s, the brawn of the squad was also required to clear the ice after large snowfalls. (Courtesy of Noble & Greenough School.)

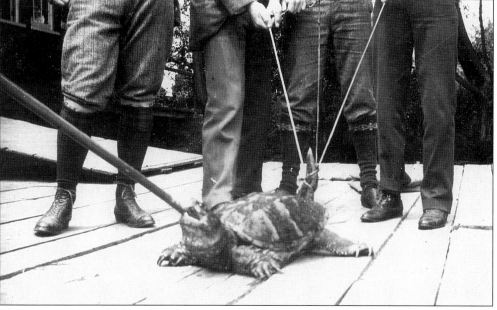

There were plenty of fish and turtles in the Charles two and a half centuries after Dedham was settled. Snapping turtles are aggressive when cornered, so they need to be tied and given something to bite, so all can marvel at their size and power. They could snap that stick in two. This turtle was caught in the summer of 1897 by J.D. French.

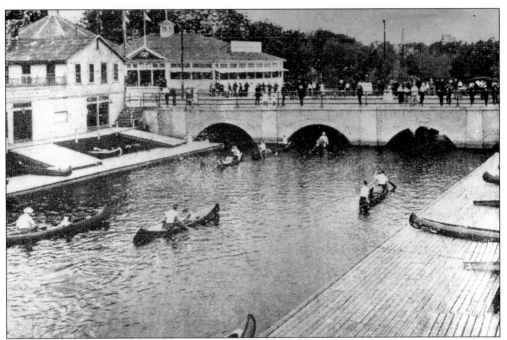

The stone bridge connecting Bridge and Spring Streets, West Roxbury, was widened by concrete in 1916. Because trolley lines from Boston and Wellesley ended there, it became a recreational area. There was Samoset Boat Club, at least four liveries for canoe rental, Moseley's for dancing, and a carousel, pictured on the other side of the bridge.

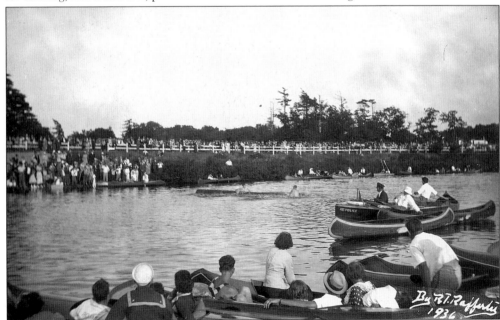

Before World War II, a popular afternoon of competition between the canoe clubs included shell races and water sports at Riverdale Park. Bucket race, tilting, tail end race, upset race, and gunwale race were the names of the competitions. Nick Nickerson is the policeman sitting in the Boston Police boat.

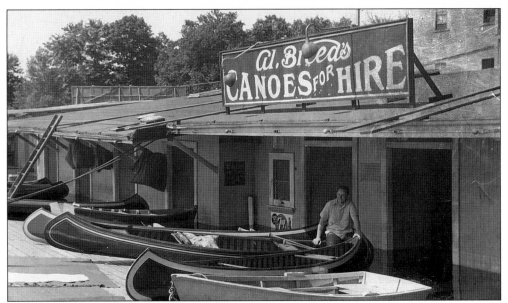

Water was high enough during the July 1938 flood to go paddling inside Breed's boathouse. Al Breed's father had bought the building in 1916. The Breeds rented canoes and rowboats there until 1940. On October 22, 1940, a fire originating in the Log Cabin Café (formerly Ammidown's Boathouse) destroyed it and Breed's boathouse and residence. Dedham's fire chief, Henry J. Harrigan, died in the fire.

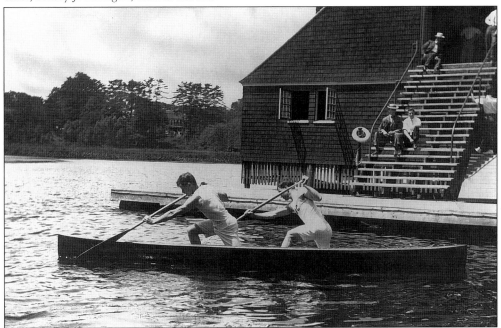

Here are George B. Ames and George C. Merritt in a tandem boat at the Dedham Boat Club. They were the 1908 and 1909 Single Blade champions of the Eastern Division, American Canoe Association. Crews had begun forming in the mid-1800s for competitive racing. One member of the Dedham Boat Club was Fred Brodbeck, a successful racer who also manufactured canoes near the Ames Street Bridge.

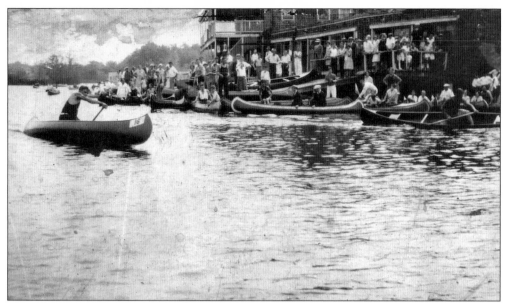

Al Voke is competing in a 26-mile Charles River marathon that started in Medfield. He has just passed the Spring Street Boat House and is about to make the last turn to the finish line at the Samoset Club Boat House float. This marathon was an annual event held all through the 1930s.

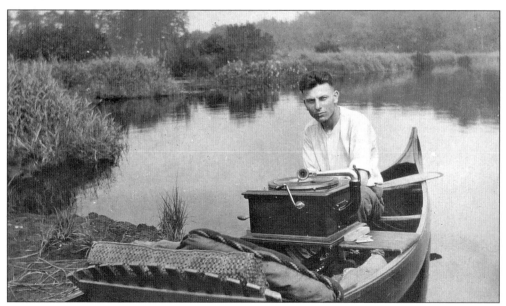

Before the portable radio, one could enjoy music on the Charles River by bringing along a musical instrument or Victrola. Here is Lester Cook set up in his canoe at the water's edge. In the evenings, however, one anchored under Moseley's open windows and listened to band music. In earlier days, evening choral concerts from the riverbank, near what is now Noble & Greenough School, entertained canoeists gathered on the river.

Six

HOUSES

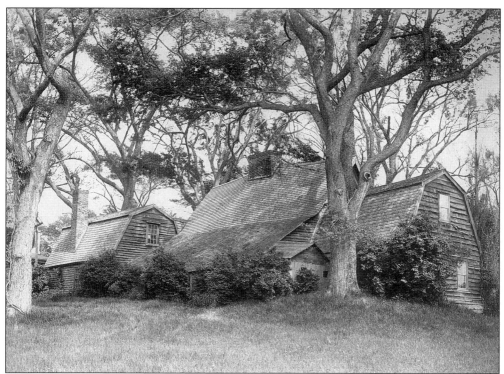

The Fairbanks House, 511 East Street, now open to the public, is the oldest timber-frame house in America. It was built *c.* 1636 by Jonathan Fairbanks and was home to eight generations of Fairbanks family members. The original house, with its steeply pitched roof, soon had the lean-to addition, shown in this late-19th-century photograph of the north elevation of the house. The east and west wings, with their gambrel roofs, were added in the 18th century.

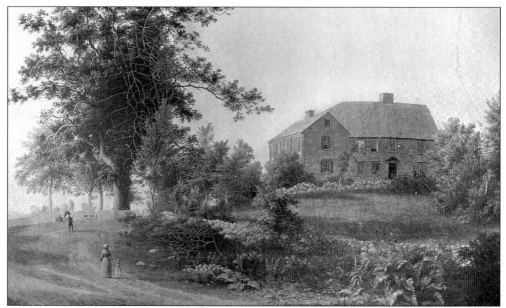

William Avery built this 17th-century house on East Street, and his descendants lived there for 200 years. The original portion of the house faced south with the late-18th-century Federal addition facing the street. The building was demolished in 1880. The oak tree standing in front, known as the Avery Oak and appearing on the town seal, was brought down by a thunderstorm in 1972.

The Fales House, built before 1684 by James Fales, was located on the east side of Cedar Street, just south of the railroad bridge and north of Turner Street. Fales was one of Dedham's first settlers and a signer of the covenant under which the town was organized. The house was torn down in 1875.

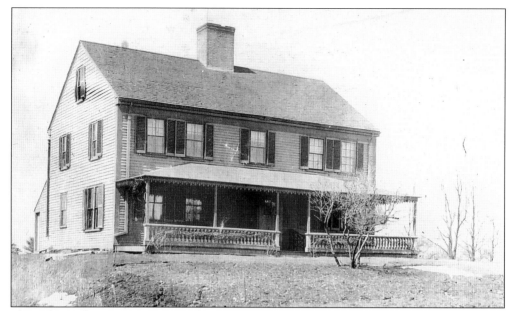

The Fisher-Whiting House, 219 Cedar Street, was built by the Fishers as a single-story dwelling with an L-shaped plan. It was redesigned in 1761 to make it square, and a second story was added. Joseph Whiting owned the house in the late 1700s. When Sally Dresser Church acquired it in 1872, the house was in disrepair. She considered tearing it down but was persuaded to restore it instead.

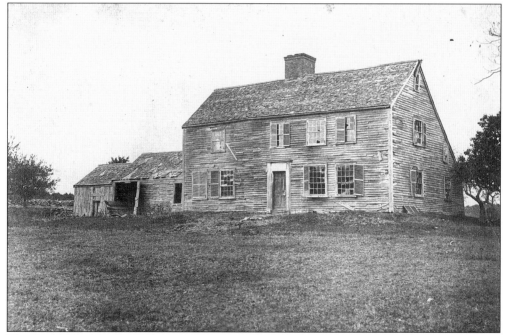

The Guild House on East Street, near the corner of Madison Street, was built by John Guild on a 12-acre lot of land before 1682. Capt. Joseph Guild, who was at Fort Ticonderoga for the winter of 1776–1777 during the Revolution, lived here before buying Riverdale Farm. The house was torn down prior to the Civil War.

The Gay family built this house at 210 Highland Street in the late 17th century. After Capt. Timothy Stowe acquired the property in 1787, it is reputed to have been used as a coaching tavern, due to its proximity to the Boston Post Road. Subsequent to this 1893 photograph, the house was significantly enlarged and modified in the early 20th century, although some of the early fireplaces, paneling, and beams remain.

The Thomas Metcalf House at 507 Bridge Street, also known as Riverdale Farm, was built c. 1700. Besides the Metcalfs, the house was home to the Guild family and to the Aaron Fisher family. The house, originally on the banks of Motley Pond, Charles River, was moved back from the pond and later moved again to make way for the Nickerson Castle. The house was torn down after 1893.

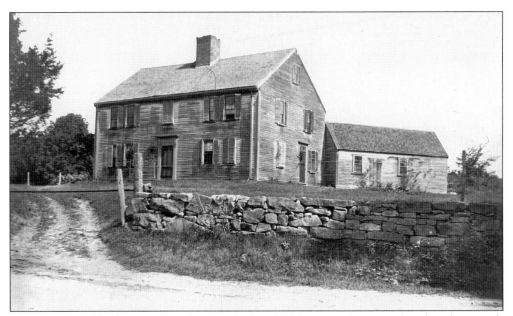

The Wilson-Hildreth House was built *c.* 1745 at 387 Common Street. After this photograph was taken in 1903, the house was purchased by William Nickerson and underwent extensive remodeling in 1907 and 1913. In 1998, the house was moved to Bemis Road and restored to its 18th-century appearance.

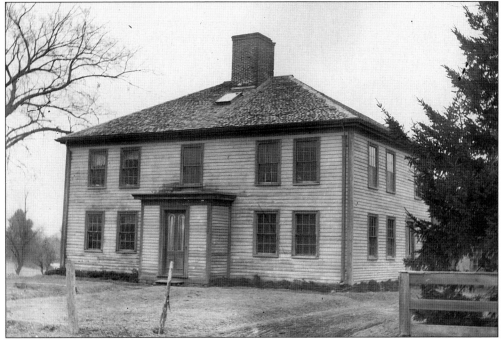

The Fuller-Onion House at 387 West Street was built *c.* 1735 by Hezekiah Fuller. The back ell of the house was older, having been built by the previous owner of the property, Eleazer May. The house was owned and occupied by members of the extended Fuller-Onion family well into the 20th century.

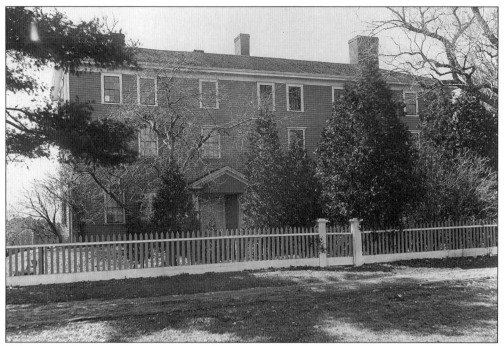

The original house on this location on Hooper Road, just off Sprague Street, was known as the Nelson-Luce-Sprague House. Dr. John Sprague had two houses at Dedham Low Plain, both of which burned in April 1765. He immediately built a new mansion, 75 feet long by 25 feet wide. Merchant Richard T. Sprague lived here when this photograph was taken in 1890.

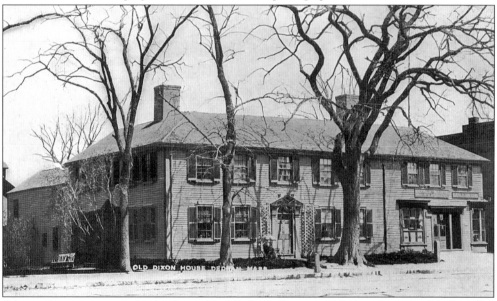

George Dixon acquired this land at 601–603 High Street in 1819 and presumably built his house shortly thereafter. Dixon established an apothecary's shop in the ell of the house where concoctions such as Lee's Bilious Pills, Dumfrey's Eye Water, and Wheaton's Itch Ointment—all made in Dedham by Wheaton & Dixon—were sold. The house was torn down in 1894, replaced by the Dedham Institution for Savings building.

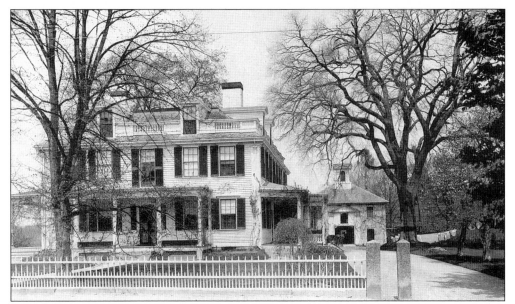

Samuel Dexter built this home at 699 High Street in 1762. The original house, two stories with dormer windows in the hip-roofed attic, went through several renovations, including the 1901 addition of a full third floor by the Burgess family. This is Dedham's house where Gen. George Washington did sleep on the night of April 4, 1776, en route from Boston to New York.

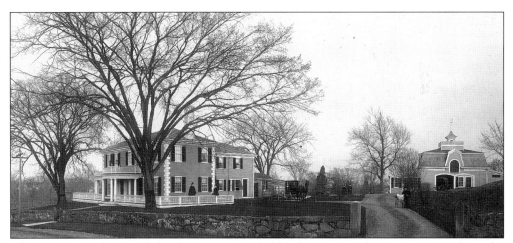

Edward A. French owned this house at 162 Highland Street, at the intersection of Lowder Street. His Federal-style home, with two end chimneys, and his barn, with its cupola, appear on an 1876 bird's-eye map of Dedham, by George Whitfield. A century before satellites could pick out ground images, such maps were dense with accurate architectural sketches of buildings, presented as actual streetscapes.

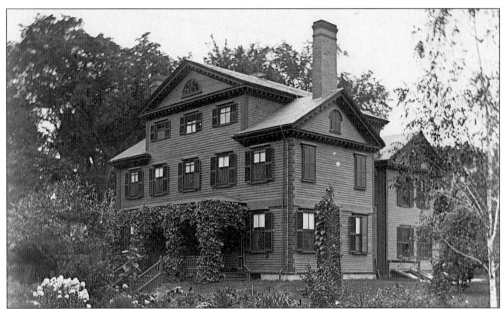

The Richards House at 97 Court Street is reputed to have been designed by Boston architect Charles Bulfinch and was built in October 1790 by John Lovell. For 114 years, it was the home of the Richards family, who modified the back ell and side wings. In 1918, Robert Morse turned it into the Dedham Inn, which was later operated by George Thorley. The house burned in the 1930s.

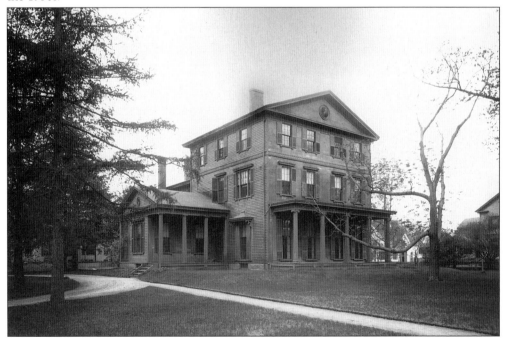

This house at 700 High Street, at the corner of Bullard Street, was built by the Bullard family in the late 18th century. In 1910, it became a school variously known as Miss Faulkner's, Miss Hewins, and, finally, Dedham Country Day School. The house was demolished in the early 1960s. In 1883, the Isaac Sprague House was moved from Medford to stand on this lot.

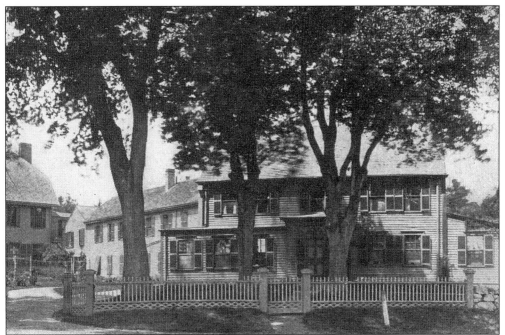

Eliphalet Pond built this house at 963 Washington Street *c.* 1727. His son, first register of deeds of Norfolk County, kept county records here. From 1864 to 1911, the house served as the Temporary Asylum for Discharged Female Prisoners. Renamed the Chickering House after Hannah Balch Chickering (the moving force behind the asylum), the house was transformed into a nursing home for women and children. It was demolished in 1972.

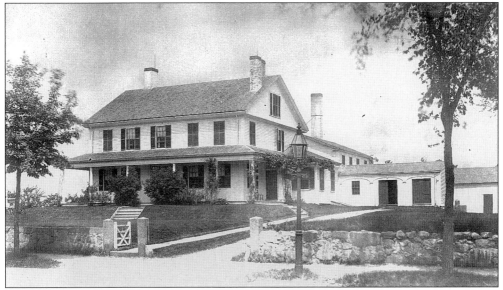

Thomas Barrows had this High Street house built in 1834. A wool manufacturer, Barrows worked for Benjamin Bussey and the Maverick Woolen Mills and then purchased and operated the Norfolk Manufacturing Company at the old Stone Mill until his retirement in 1872. He lived in this house until his death in 1880. In 1959, the house was torn down to make way for a parking lot for St. Mary's Church.

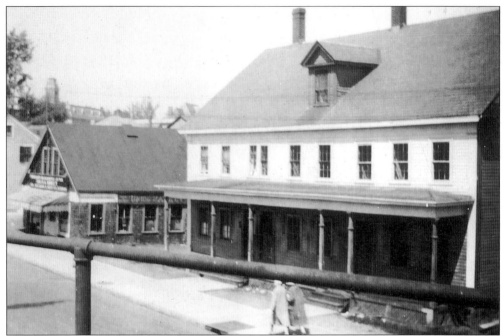

This building was constructed on Village Avenue for the county sheriff at the Norfolk County Jail. Around 1880, the house was moved from Village Avenue to High Street, as shown in this photograph. In 1932, the house was demolished to make way for the Route 1, now officially the Providence Highway overpass.

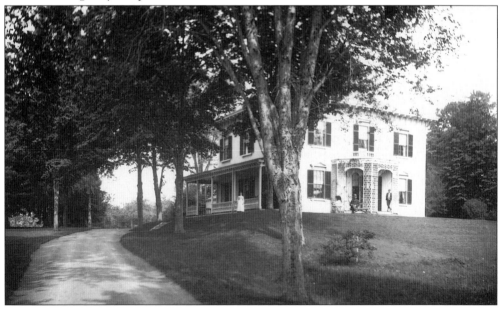

This house, owned by the Horatio Chickering family, was located on Walnut Street. The house was subsequently occupied by Wendell Endicott, son of Henry Endicott, builder of the Endicott Estate. After Wendell moved out to build his own Endicott Estate at 80 Haven Street, the Chickering House was demolished and its land incorporated into that of the East Street Endicott Estate.

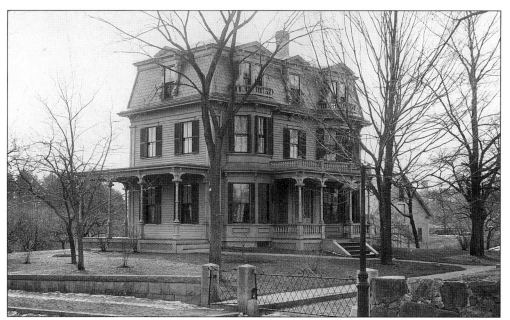

Otis Withington, for a long period Dedham's leading contractor and builder, built this Second Empire house on High Street (near what is now Recreation Road) in the late 19th century. Later, he built a large addition to the house in the same style. Home to the Storrs, Greenhood, and Welch families, it was demolished in 1966 to make way for the high school expansion.

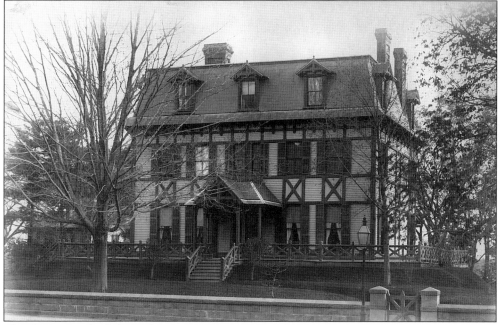

This house was built by Fisher Ames in 1795 near the Ames family's Tavern at the present intersection of High and Ames Streets. In 1868, Edward Stimson acquired the property and completely remodeled the house in the Stick style, as shown in this late-19th-century photograph. In 1905, the house was removed to the end of River Place to make way for the Norfolk County Registry of Deeds.

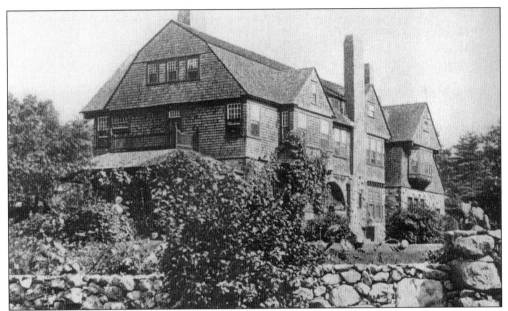

Woodleigh, at the corner of Walnut and Mount Vernon Streets, was a large stone and shingle house built in 1884 by Robert M. Bailey, an artist and architect. The house also had a large barn with a bowling alley. The house was torn down in the 1930s and five houses built on its lot. Bailey designed and built numerous houses on Walnut Street and Woodleigh Road.

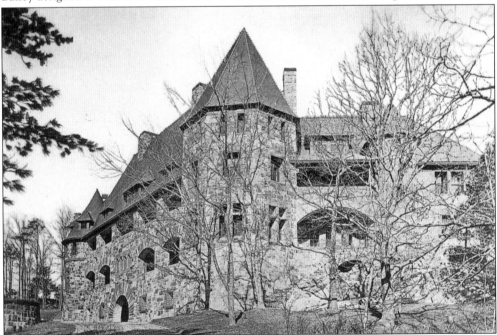

Riverdale, also known as "the Castle," is a grand Romanesque residence, designed by Shepley, Rutan and Coolidge and built for Albert Nickerson in 1888. Albert Nickerson was president of the Arlington Woolen Mills and a director of the Atchison, Topeka and Santa Fe Railroad. The Nickerson family sold the house and its surrounding property to the Noble and Greenough School in 1921.

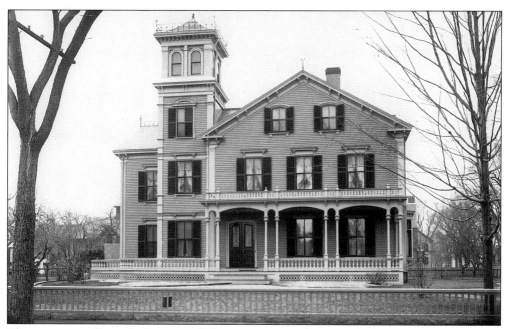

This was originally an Italianate-style home at 734 High Street, built c. 1855 by William J. Doole. A major remodeling in 1915 stripped the house of its original asymmetrical Victorian design and transformed it into a Georgian Revival residence. As shown below, it is scarcely recognizable as the same house on the exterior. On the interior, however, the two west parlors from the original house survive.

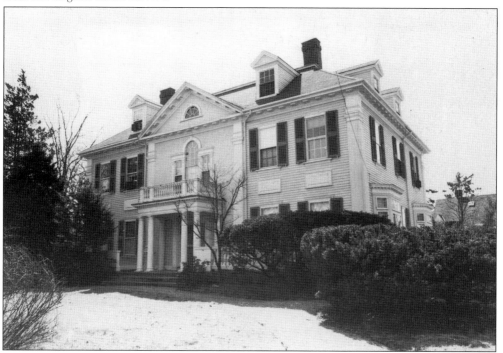

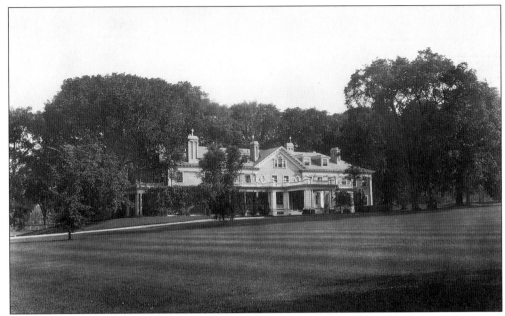

Henry Bradford Endicott, founder of the Endicott-Johnson Shoe Corporation, built this home at 656 East Street in 1904. On his death, the house passed to his adopted daughter, Katherine. On her death in 1966, Katherine left the property to the town. The estate was briefly considered by the state as a possible official governor's residence, but the property eventually reverted to the town and is now used for local functions.

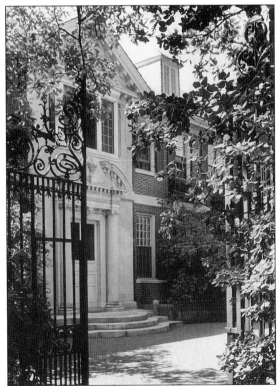

The Francis Skinner House at 85 Lowder Street was designed by Guy Lowell and built in 1906. It is a country estate in the style of the English country estates. The roof originally had a garden one-third its full size, and the house was surrounded by English gardens. Later known as the Shea Estate, the house is currently owned by Urseline Academy.

Seven
ARTISTS AND
OTHER NOTABLES

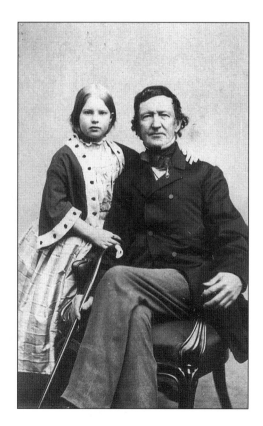

Alvan Fisher (1792–1863) is pictured here
with his granddaughter Adaline Swan Fisher.
He was a student of John Ritto Penniman and
painted the copy of Gilbert Stuart's equestrian
portrait of Washington that now hangs in the
Dedham Town Hall lobby. Fisher was a
prolific painter of portraits, landscapes, and
animals, traveling extensively in our country
and abroad. From 1840, his home and studio
were located at 26 School Street.

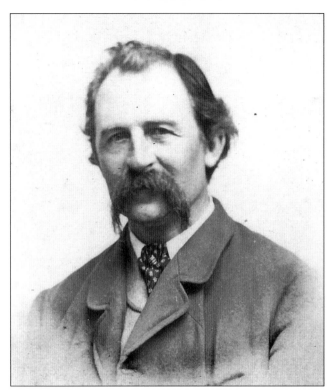

Henry Hitchings (1823–1898) lived at 41 Highland Street. Sometimes called "the father of the evening drawing school," Hitchings was an early proponent of art as a course of study in the Boston public schools, where he served as director of drawing for 20 years. He was also one of the founders of the Boston Art Club. Hitchings's landscapes include paintings and sketches of various Dedham landmarks.

The venerable Charles E. Mills (1856–1956) and his sister Ellen Mills lived at 63 School Street from 1888 until 1954. He had a studio in the Greenleaf building in Dedham Square. Mills was noted for his murals in the Franklin Institute. He designed stained-glass windows for Harvard's Memorial Hall and Boston's Trinity Church. Some of his paintings of Dedham hang in the Dedham Public Library.

Katharine Pratt (1891–1978) was one of two highly acclaimed women silversmiths during her lifetime. As a child, she lived at 41 School Street with her parents, Dr. John W. and Marion C. Pratt. Later, she lived at 45 School Street, where, in a small room at the back of the house, she practiced her craft. Dedham artists shown in this book are all represented in the Dedham Historical Society Museum.

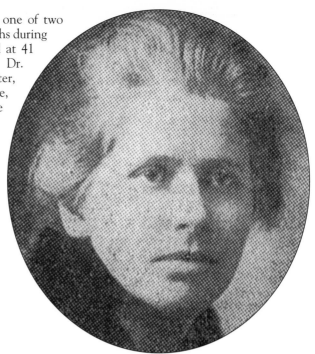

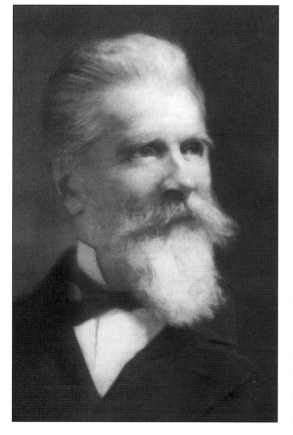

In 1883, Robert M. Bailey (1849–1935), an artist and architect, purchased 29 acres of land in what is now the Woodleigh Road area for $14,800. There he built Woodleigh, a large stone house with a long facade facing Walnut Street. Stone gateposts, which remain today, marked the long driveway. He went on to design and build homes for his children. These homes became 14, 35, and 71 Woodleigh Road and 218 Walnut Street. (Courtesy of Grogan & Company.)

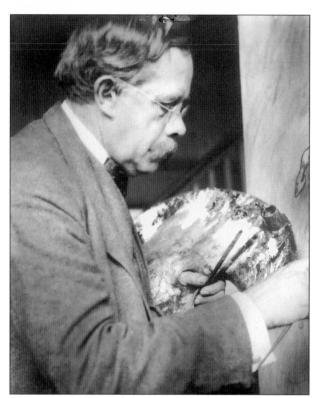

Philip Leslie Hale (1865–1931) and Lilian Westcott Hale (1881–1963) came to Dedham from Boston in 1908, just before their only child, Ann Westcott Hale (called "Nancy"), was born. Philip Hale was an accomplished artist as well as a dedicated teacher, critic, and writer. Lilian was a talented and popular artist who came to Boston to study at the Museum School, where Philip was a member of the faculty. The Hales are pictured in their home at 223 Highland Street, where they had moved by 1912. It was here in her studio that Lilian drew her well-known charcoals and painted her portraits, many of local residents. Nancy Hale (1908–1988) was a successful novelist and short story writer. Her novel *Life in the Studio* was about growing up as the daughter of artists.

Born in Medfield, Hannah Adams (1755–1831) was the first American female professional author. Sickly as a child, she was unable to attend school but took advantage of her father's extensive library and tutoring from some of his boarders. Adams lived in Dedham while writing her *History of the Jews*, which was completed in 1812. Her other works include *A Summary History of New England* and *Letters on the Gospels*.

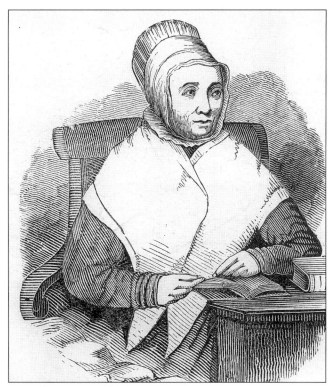

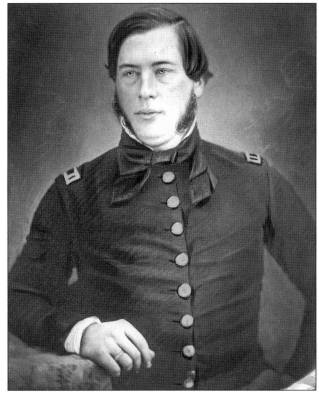

Shown here is George Horatio Derby (1823–1861), son of John and Mary (Townsend) Derby. Born in Dedham, he worked for a grocer in Concord and on a farm in Medfield before going to West Point. He graduated in 1846 and fought in the Mexican War. Known also as "John Phoenix," he is remembered for his clever wit and many entertaining writings.

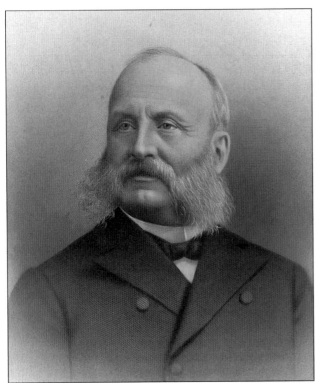

Erastus Worthington (1828–1898) served Dedham in numerous capacities. An author and historian, Worthington was also a lawyer, trial justice, clerk of courts, town moderator, and member of the school committee. He was chosen to give the historical address at Dedham's 250th anniversary. His speech ran to 43 pages in the published record for the day.

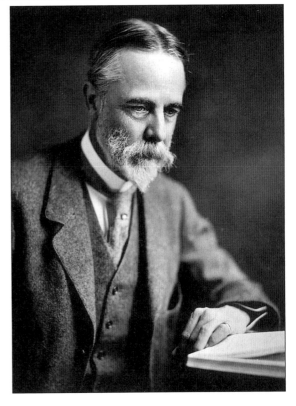

Frederic Jessup Stimson (1855–1943) was a statesman, ambassador, Harvard professor, author, and lawyer who served as assistant attorney general of Massachusetts. In local business, Stimson was active in the Dedham Institution for Savings and the Dedham National Bank. He also helped organize both the Dedham Polo Club and Dedham Boat Club.

Samuel Dexter (1726–1812) was the son of the Reverend Samuel Dexter, the fourth minister of the Dedham First Church. Samuel Jr., a Harvard-educated merchant, served as a member of the Governor's Council (1768–1774). He built his home at 699 High Street in 1761. He was a strong supporter of education and a generous benefactor of the schools of Dedham. The Dexter School was named in his honor.

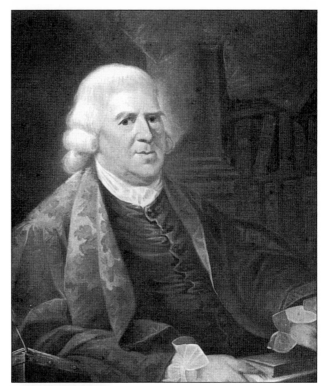

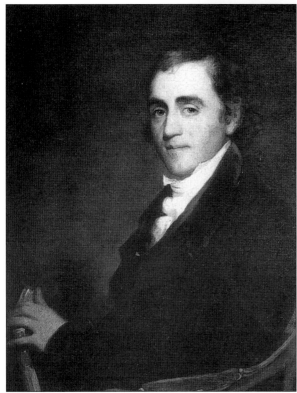

Fisher Ames (1758–1808) was the son of Dr. Nathaniel Ames (1708–1764) and Deborah (Fisher) Ames. As a member of the U.S. House of Representatives, Ames served in the first through fourth Congresses from 1789 to 1797. He was an influential Federalist and a noted orator. He married Frances Worthington in 1792 and, in 1795, built his home on High Street, on the site of the Norfolk County Registry of Deeds.

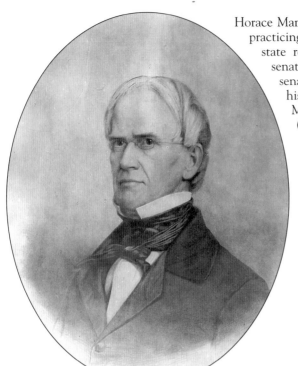

Horace Mann (1796–1859) lived in Dedham as a practicing lawyer from 1823 to 1837. He was a state representative (1827–1833) and state senator (1833–1837), serving two years as senate president. He became famous for his work and reports as secretary of the Massachusetts State Board of Education (1837–1848). Serving in Congress as a Whig (1848–1853), he gave powerful antislavery speeches. In the last eight years of his life, he was president of Antioch College.

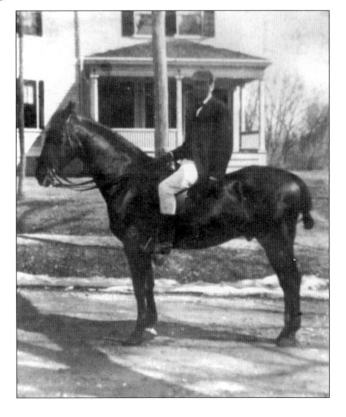

The first Jewish Supreme Court justice, Louis D. Brandeis (1856–1941), had a home at 194 Village Avenue. Shown here on his horse, Brandeis enjoyed rides with the Dedham Polo Club and family canoeing on the Charles River. Known as a "people's attorney," Brandeis was also an author. He was outspoken, criticizing monopolies, railroad companies, and money trusts. He also supported savings bank life insurance and Zionism.

Hannah Shuttleworth (1800–1886) was the daughter of Jeremiah Shuttleworth, the first Dedham postmaster. Their family home at the corner of Church and High Streets housed the Dedham post office. She left this property and some of the funds that she inherited from the estate of Dr. Nathaniel Ames the younger to the Dedham Historical Society. Other bequest went to the Dedham Public Library and a Dedham charity fund.

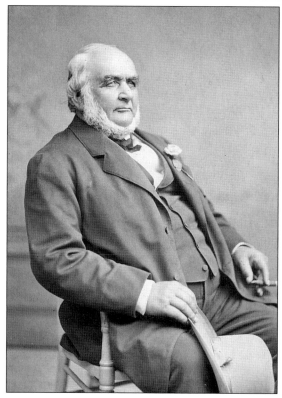

Eliphalet Stone (1813–1886) settled in Dedham in 1833. His house is now numbered 19 Mount Vernon Street. He was a major landowner along High Street. He served several years as a state representative. An ardent supporter of the Dedham men in the Civil War, he worked tirelessly for the welfare of the wives and families who remained in Dedham. He gave land to the town for what became Stone Park.

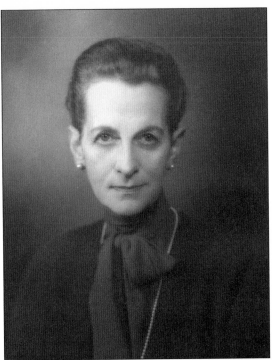

Katherine Endicott was the adopted daughter of Henry Bradford Endicott (1853–1920). Her mother, Louise Clapp Colburn, was Endicott's second wife. Henry Bradford Endicott, an 1871 graduate of Dedham High School, was co-owner of the Endicott-Johnson Shoe Corporation, one of the largest shoe manufacturers in the world. He built the estate at 656 East Street in 1904–1906. She willed the house to the Town of Dedham in 1967.

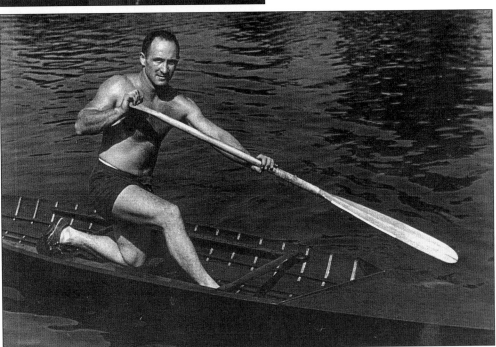

At age 40, canoeist George Byers (1916–1995) competed in the 1956 Olympics in Melbourne, Australia. A member of the Samoset Canoe Club and a five-time winner of the 26-mile Charles River Marathon, he teamed up with racing partner Dick Moran of West Roxbury at the Olympics. Byers and his wife, Ruth, had six children. He owned and operated a local fuel oil business. (Courtesy of Ruth A. Byers.)

Eight
TRANSPORTATION

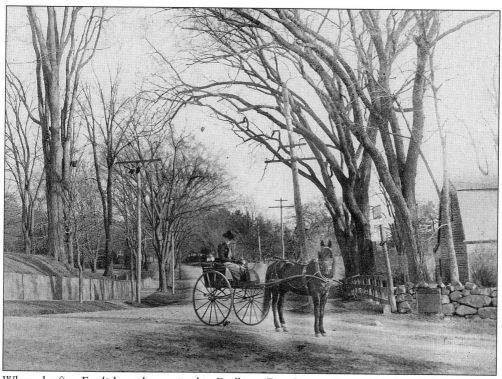

When the first English settlers arrived in Dedham, East Street, pictured by the Fairbanks House *c.* 1900, was just a well-worn American Indian trail. It was later part of the historic post road, established in 1692, that ran between Boston and New York. In 1718, the first stagecoach line in New England began regular trips between Boston and Bristol Ferry, Rhode Island, traveling over this road.

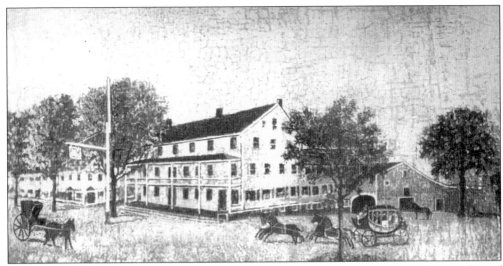

In 1792, Timothy Gay built this tavern in the center of Dedham, where the Knights of Columbus building now stands. The Citizens Stagecoach Line (of which Timothy Gay was president) made regular stops there on its way from Boston to Providence. The tavern provided a change of horses, needed about every 10 miles, and refreshments for the passengers. Until it burned down in 1832, the tavern was known by the names of its many proprietors: Clap, Smith, Polley, Alden, and Bride, the proprietor when this picture was painted. The Phoenix House (below) was built on the same site in 1834. The stage continued to make regular stops there for a few more years, but the completion of the Boston and Providence Railroad in 1837 soon ended the days of the stagecoach. The Phoenix House continued to operate until 1880.

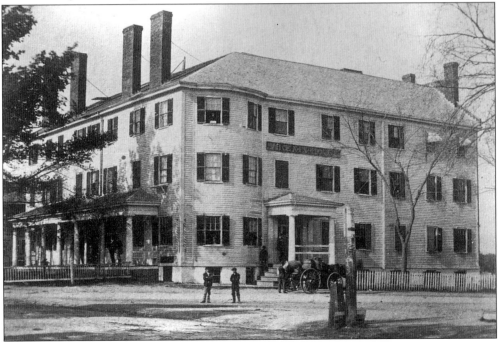

Highland Street is seen in this view taken from Federal Hill, looking toward Court Street. Stagecoaches traveled over this road as early as 1765. In 1803, the Dedham section of the Norfolk and Bristol Turnpike ran along Washington, High, Court, and Highland Streets. The road supported many taverns known successively as the Fisher-Ames-Woodward Tavern, the Gay Tavern, the Howe-Punch Bowl-Columbian Tavern, and the Marsh or Norfolk Tavern.

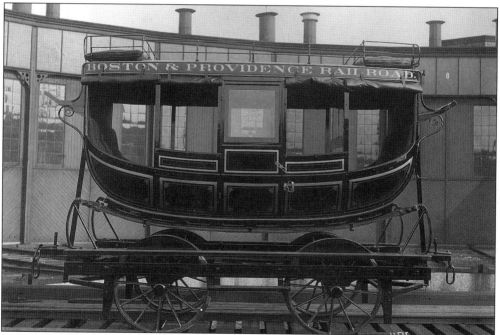

In 1835, the Boston and Providence Railroad built a branch from Lower Plain (Readville) to Dedham Center, connecting with the main line from Boston to Providence. The first railroad cars resembled stagecoaches, which they were soon to replace. They were drawn by horses. This continued until c. 1837, when steam locomotives replaced the horses.

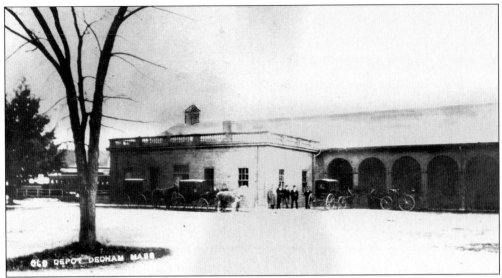

In 1837, this depot was built of stone in Dedham Center, after the first station burned. A waiting room was added in 1850, and the depot served Dedham until 1882, when it was torn down. By 1851, Dedham had eight trains a day to Boston at a fare of 25¢. In 1882, the Boston and Providence Railroad listed 19 trains a day from Dedham to Boston.

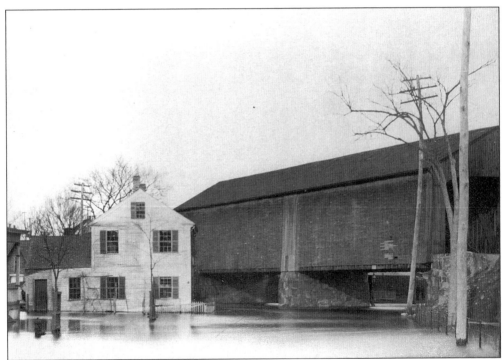

In 1850, the Boston and Providence Railroad ran the Dedham trains in via West Roxbury, with this covered bridge spanning the High Street–East Street intersection. It was painted bright red and it was said that the rumble of the trains passing through it could be heard all over town. When this photograph was taken, Dwight's Brook had overflowed, as it often did, flooding the intersection under the bridge.

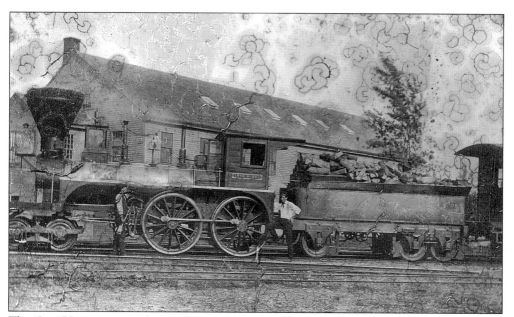

The "Iron Horse," pictured in Dedham in 1850, was a wood-burning engine. The wood was cut by horsepower at the depot. Walter White of Dedham (left) was acting as fireman. The engineer (right) is thought to be James Boyd. In *Mid-Century Memories*, William Horatio Clarke said the locomotives "Suffolk" and "Norfolk" were used regularly. "Tiot" or "King Phillip" occasionally ran up to Dedham.

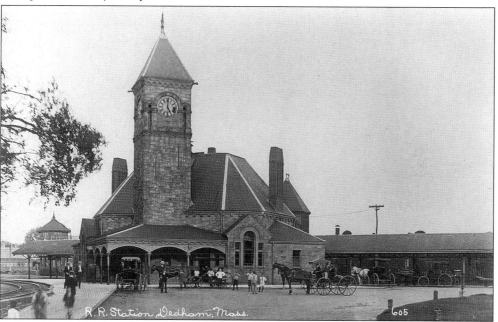

In 1882, the Boston and Providence Railroad hired Sturgis & Brigham of Boston to design a new depot for Dedham Center. It was an elegant structure, built of Dedham granite, that reflected the importance of Dedham as a thriving transportation center. Railroad service peaked in 1898, with as many as 60 trains a day stopping in Dedham. The station was abandoned in 1933 and torn down in 1951.

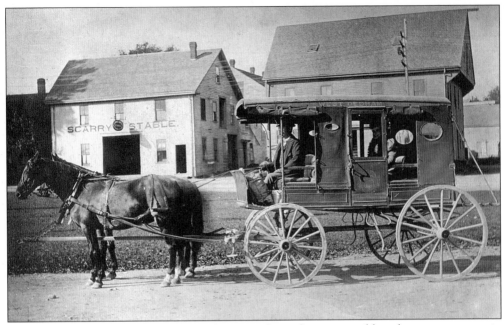

The West Dedham Stage, Joseph Fisher seen here driving, would pick up passengers in surrounding areas and drop them at the depot in Dedham Center, where they could board the train to Boston or New York. Scarry Stables, seen in the background, was located opposite the station on Eastern Avenue, approximately where the CVS parking lot is now located.

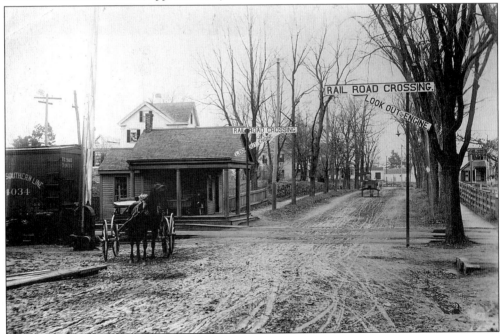

Stone Haven Station was located on the Dedham branch line at Mount Vernon Street. It was named after Col. Eliphalet Stone, who had represented Dedham in the legislature in the 1860s. He donated the building for a waiting room. Colonel Stone's house can be seen next to the station. This view looks north toward High Street, before the overpass was built.

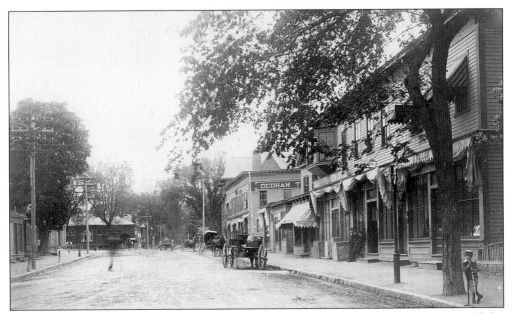

Dedham Square is shown *c.* 1890, when the streets were unpaved and wagons were still the main method of transportation. At times, everything in the square was covered with dust, stirred up by the horses and wagons. Watering carts were used to keep down the dust. The superintendent of streets reported that in 1904 a new cart was purchased, making a total of seven carts owned by the town.

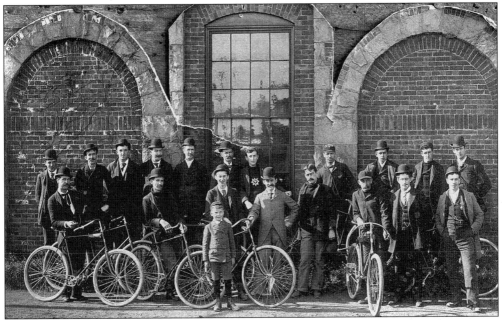

In the 1870s, the first high bicycle appeared in Dedham, although cycling did not become popular until the introduction of the modern safety bicycle in the late 1880s. The Dedham Cycle Club (shown here) was organized in 1892. They held the club's First Annual Cycle Meet in 1894, drawing nearly 8,000 people into Memorial Square and along High Street to witness the races.

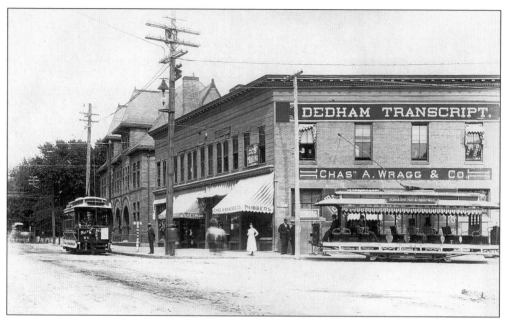

Between 1894 and 1899, six trolley car lines were built in Dedham, connecting Boston with the suburbs. Dedham was an interchange point for lines directly connected to Needham, Westwood, Norwood, West Roxbury, and Hyde Park. The streetcar on the left is headed for Medway via Westwood, Dover, Medfield, and Millis. The open trolley has just arrived from Forest Hills, a 30-minute ride. The fare was 5¢. For the first time, there was public transportation that most people could afford. Competition developed with the Boston and Providence Railroad. When there was too much snow and ice for the streetcar to operate, the pung (below) was used between Dedham and Westwood.

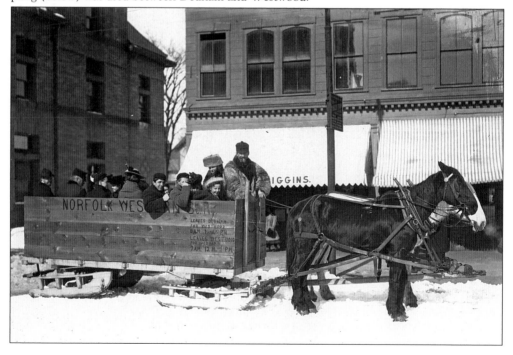

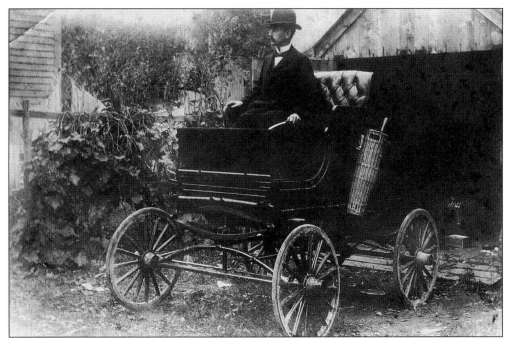

Early automobiles were little more than buggies equipped with motors, but having no tops, windshields, horns, or lights. Dr. Harry K. Shatswell, a Dedham dentist, invented this steam car in 1900. In 1903, the first year of the licensing of drivers and the registration of motor vehicles in Massachusetts, there were 11 "horseless carriages" registered to Dedham residents. Speed limits were 10 miles per hour in town, 15 in the country.

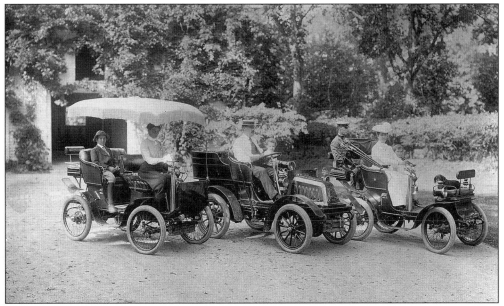

Theodore P. Burgess, of Dedham, imported three automobiles from France in 1900. For months after their appearance in town, their coming down the street (announced by loud engine noises) caused all activity to cease. They were told to stay off the main highways and away from the railway station, the country club, and race meets because the noise frightened the horses.

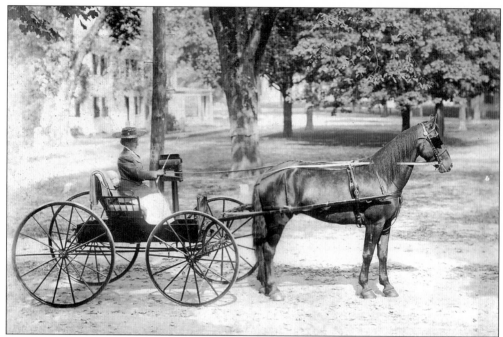

In 1911, when this photograph was taken in Franklin Square, the horse and buggy was still a popular means of transportation. Martha May (Baker) Brown, of Dedham, often traveled around in her buggy, pulled by her favorite horse, Tommy. That year there were three carriage builders in Dedham: John V. Fell, 50 Church Street; Edward L. Small, off Emmet Avenue; and Elias B. Swedberg, 417 Washington Street. (Courtesy of Adaline Grearson.)

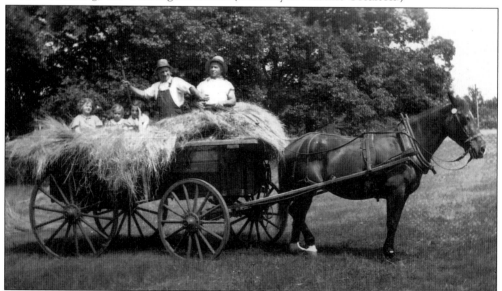

Dennis Sullivan (right) is giving his three granddaughters and an unidentified worker a ride on the hay wagon at Rodman's estate, Lowder Street, c. 1936. From left to right are Mary Gilbert, Eleanor Sullivan, and Claire Sullivan. Dennis Sullivan worked for the Rodmans for almost 50 years. He was their driver, took care of the horses, and was caretaker of the estate. (Courtesy of Dennis Sullivan's grandchildren.)

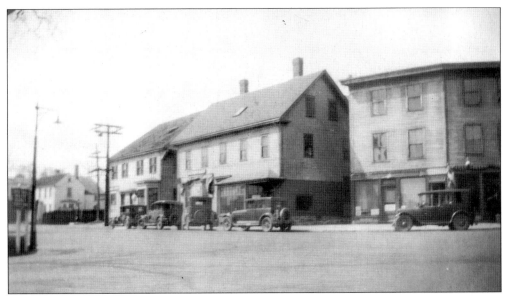

This is a photograph of Eastern Avenue as seen from High Street in 1927. Cars had become so popular by then, there was little need for the Electric Street Railway. By 1932, there were no streetcars running in Dedham, and buses took over their routes. Dedham Square Chevrolet, 358 Washington Street, advertised tires: "Every $2^1/_2$ seconds someone buys a Dunlop." Dedham Motors, 362 Washington Street, advertised Firestones from $5.85 to $18.35.

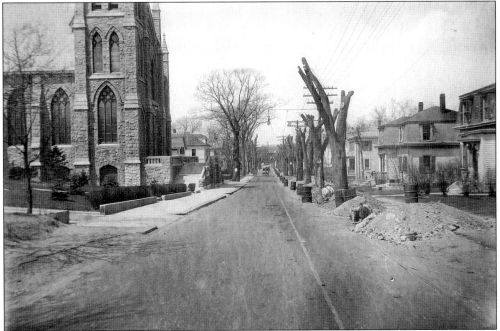

Roads had to be improved to ease traffic problems that developed in the 1920s. High Street was widened by taking four feet on the north side and from two to seven feet on the south side between East and Mount Vernon Streets. Starting in April 1928, electric car tracks were taken up and 19 large elms were removed. This supplied local residents with firewood for the following winter.

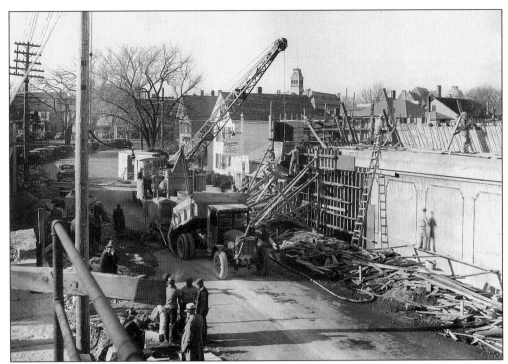

Route 1, now called the Providence Highway, through Dedham, was built in the early 1930s, following a rail bed that had been the Walpole Railroad Company to Walpole and later the Norfolk County Railroad to Norwood. Route 1 was one of the first major highways in the nation, connecting Maine with Florida. Work on this overpass carrying Route 1 over High Street took place in 1932.

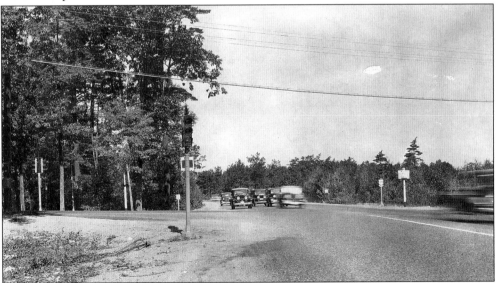

This is Old Route 128 in a view looking north at the High Street intersection. In the early 1900s, streets around Boston were connected to form the highway. As early as the 1920s, extra police officers were needed on weekends to deal with the traffic. The new limited-access, divided highway now known as Route 128 was built in 1952, destroying most of the town forest.

Nine

BENCHMARK EVENTS

The Old Village Cemetery on Village Avenue was Dedham's original burial ground, in use at least as early as 1638. It continued as the town's sole place of interment for almost 100 years, until the town's various satellite villages were sufficiently developed to require their own cemeteries—although Dedham proper did not establish an alternative location until Brookdale Cemetery opened in 1878.

The Pillar of Liberty was erected on the southwest corner of High and Court Streets in 1766 by Dr. Nathaniel Ames the younger and the Dedham Sons of Liberty. The tall wooden column was surmounted by a bust of William Pitt, leader of Parliamentary action to repeal the Stamp Act. The granite base survives, restored to its original site on the Little Common fronting the First Parish meetinghouse.

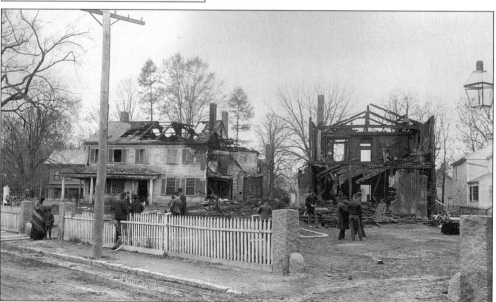

Temperance Hall burned on April 28, 1891. It was originally built as the first courthouse of Norfolk County in 1796 and then sold as surplus in 1827. For over 60 years, the building entertained a retail establishment on ground level and a second floor hall popular for local gatherings and entertainment of every kind. The fire also burned the old Howe Tavern (left) and a grain store. This view, taken from Church Street, shows the aftermath.

104

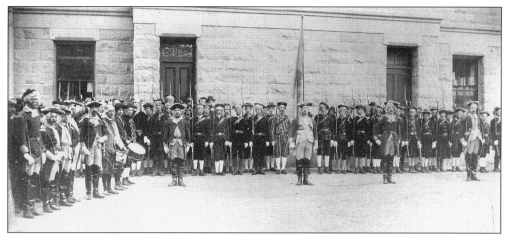

These are East Dedham men who participated in the parade of September 21, 1886, marking the 250th anniversary of the incorporation of the Town of Dedham. The *Dedham Transcript* reported that the day was ushered in by a booming cannon and pealing church bells. Grand Army of the Republic (GAR) units, fire departments, bands, and a fife and drum crops marched in the procession that was the major event of the day.

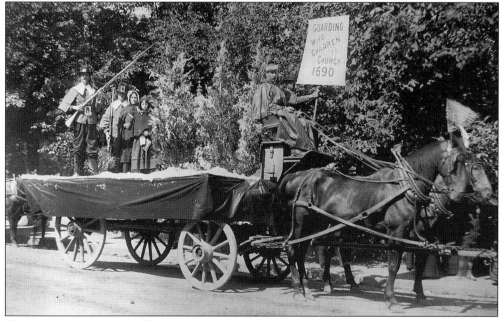

This was the sixth of nine floats in the 250th anniversary procession. Portrayed on their way to church are the settler armed with a old flintlock, Irving Donley; his son, also armed, George Paul; his wife, Mary C. Ellis; and his daughter, little Emma Donley, with the driver, unidentified. Ending the floats division were an old stagecoach, a modern tallyho, and J.E. Smith riding a fat ox, his oxmanship much admired.

This shows the up-to-date way to record family history in 1900. The 45th wedding anniversary of Henry Bigelow and Maria Fuller was celebrated at the home of James Y. Noyes, 42 School Street, on January 21, 1900. The photographer's advice was to look anywhere but at the camera; the nighttime, indoor use of a flash pan was new to Dedham, and there was concern about the possibility of eye damage. Families represented besides Fuller and Noyes, were Adams, Bigelow, Evans, Lamson, Weaver, Winch, and Withington.

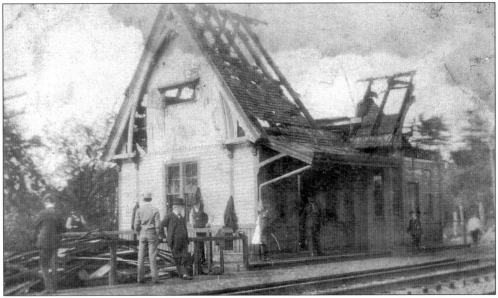

Fires destroyed many mills, taverns, and homes over the centuries in Dedham. This picture shows the collapse of the Endicott Railroad Station on September 2, 1905, the blaze started by a painter's gasoline lamp. In less than six minutes after the alarm, the fire company from the center of the town and the East Dedham Company arrived within seconds of each other. Allowing for distance, it was a dead heat.

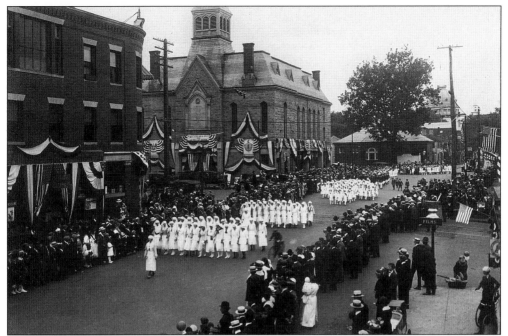

The date of May 23, 1918, was Military Day in Dedham, a patriotic rally and fundraising event sponsored by the Red Cross. Here Red Cross units march in the parade down High Street. Memorial Hall, draped in colors, stood where the police station is now in Dedham Square. Memorial Hall had been dedicated in 1868 as the town hall and a memorial to the 47 men who died representing Dedham in the Civil War.

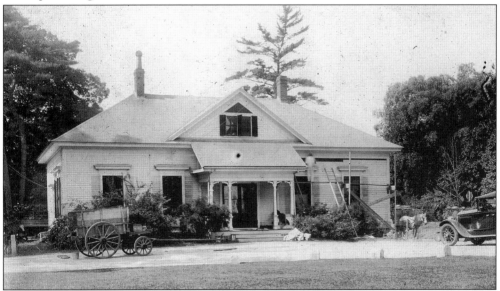

The Unitarian church cooperated with the Dedham Committee of Public Safety to open its vestry as a temporary hospital during the influenza epidemic of 1918. From October 1 to October 21, 1918, nurses and volunteers cared for 36 patients. Eight men, four women, and two newborn babies died here. Schools, churches, public meetings, and social events were canceled during the epidemic.

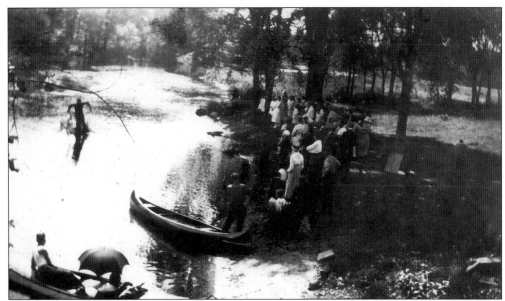

In 1919, *Anne of Green Gables*, starring Mary Miles Minter and directed by William Desmond Taylor, was filmed in Dedham, using the Fairbanks House as Green Gables. Here the cast is shown on August 9, 1919, enjoying a picnic beside the Charles River at the pumping station grounds on Bridge Street. Notices for the film to be shown at Memorial Hall stated that more than 75 Dedham people appeared in the picture. No copies of the film remain.

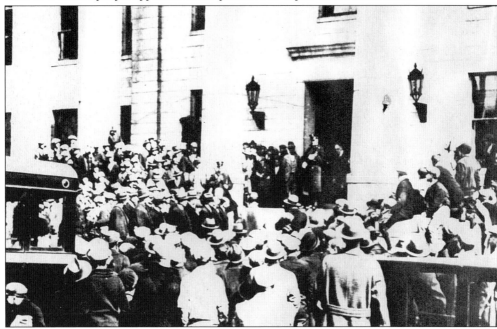

Shown here is Norfolk Superior Court on April 9, 1927, at the sentencing of Nicola Sacco and Bartholomeo Vanzetti for the murders of paymaster Frederick A. Parmenter of the Slater-Morrill Shoe Company and his guard, Alexsandro Berardelli, at South Braintree on April 15, 1920. Sacco and Vanzetti were executed at midnight on August 23, 1927, in Charlestown. This famous and controversial case still brings researchers to Dedham.

This "Memorial Seat and Tablet" at the Ames Street Bridge was dedicated in 1927 to mark the surmised probable location of the "Keye," or river shallows, that served as a landing place for river traffic at the time of the early settlers. The seat is on land owned by the Dedham Community Association, which, with the Dedham Historical Society, erected the memorial. Charles E. Mills designed both the seat and tablet.

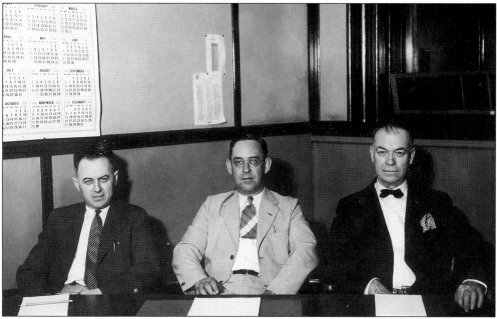

The 1936 Dedham Board of Public Welfare represents the era of the Great Depression as well as the hundreds of Dedham citizens who have given uncounted hours to the town through its history. Shown from left to right are John Brown, Edmund J. Gilbert, and Richard Mandeville. As early as 1932, the selectmen reported there were between 1,000 and 1,200 unemployed in Dedham. Dedham used many WPA projects to help the unemployed.

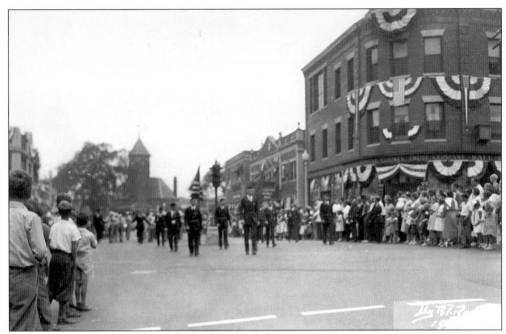

Dedham's 300th anniversary, in 1936, was occasion for a happy celebration. Robert T. Rafferty took this picture of the tercentenary parade from the corner of High and Washington Streets. The railroad station tower shows a longtime notable Dedham street vista that endured until the removal of the railroad station in the early 1950s. An estimated 75,000 people watched the parade. Fifteen towns, once part of Dedham, took part.

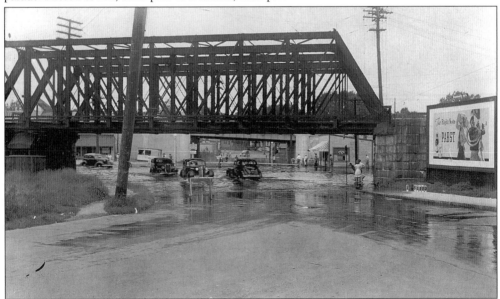

Dwight's Brook flooded the intersection of High, East, and Williams (now Harris) Streets in the Hurricane of 1938. Notable floods in 1886, 1920, and 1927 may have brought higher water, but this was the worst windstorm. Thousands of trees were blown down in Dedham. The *Dedham Transcript* reported the worst destruction on East, Mount Vernon, Washington, High, and Chestnut Streets.

Ten

SERVICE FOR COUNTRY

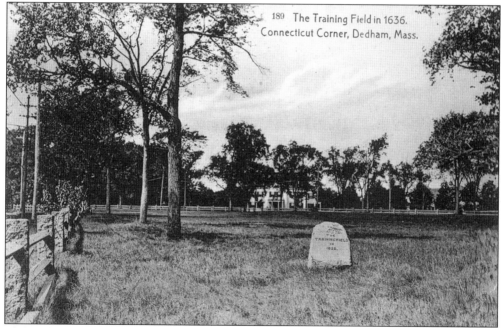

189 The Training Field in 1636.
Connecticut Corner, Dedham, Mass.

The Dedham Common was once part of the training ground set aside for the use of the military company the town was required to maintain. Records indicate at least 84 Dedham militiamen saw service in King Philip's War. Fifty-three other citizen soldiers from Dedham participated in campaigns against French forts at Lake George, Crown Point, Ticonderoga, and Louisburg during the French and Indian Wars.

The old Powder House, "built on the great rock that stands in Aaron Fuller's land," stored military supplies through the period of the Revolution and on into the 1840s. Some 678 soldiers appear on a roster of soldiers who served during the Revolution, between 1775 to 1783. Dedham Historical Society volunteer and world-famous photographer Fred Holland Day took this 1886 photograph showing his friend Myron Lochman.

Some 75 Dedham men served in the 18th Massachusetts Volunteer Infantry during the Civil War and 17 of that number were casualties. Here is the regimental camp at Beverly Ford, Virginia, just before the Wilderness Campaign in 1864. The 18th Regiment's state colors were lost at the Second Battle of Bull Run. The flag was returned from Virginia after the war to be enshrined in Hall of Flags at the State House.

This typical soldier's portrait is of Thomas Sherwin Jr. He was a teacher when he enlisted in the 22nd Massachusetts Infantry. He was wounded in the battle at Gaines's Mills, Virginia, on June 27, 1861, and was promoted major for gallant conduct. Successive promotions raised him to lieutenant colonel, colonel, and brigadier general. In the war, more than 500 men represented Dedham by birth, residence, or enlistment.

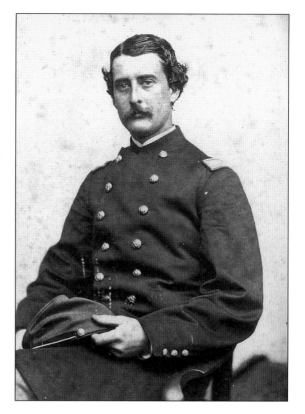

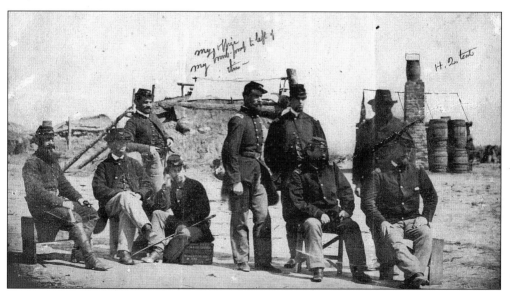

Sixty-eight men credited to Dedham served in the 35th Massachusetts Volunteer Infantry Regiment, 12 of whom paid the supreme sacrifice. The officers of the regiment are shown in this picture taken on March 17, 1865, at Fort Sedgewick (also known as "Fort Hell") during the Siege of Petersburg. John D. Cobb of Dedham, regimental adjutant, is the officer sitting on the ammunition box, fourth from the left.

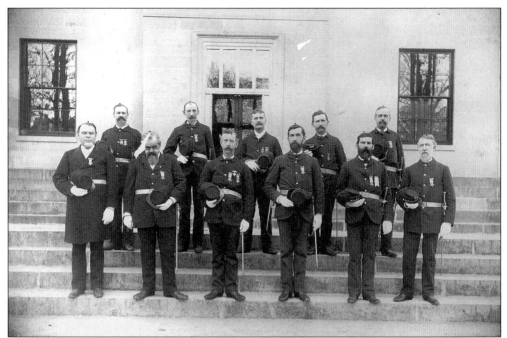

Officers of the Charles W. Carroll Post No. 144, Grand Army of the Republic (GAR), pose on the courthouse steps during Memorial Day ceremonies on May 30, 1886. This post was named after Charles W. Carroll, captain of Company F, 18th Regiment, MVI. Wounded on August 30, 1862, at the Second Battle of Bull Run, he lay unattended behind Confederate lines for three days and died while being carried from the field.

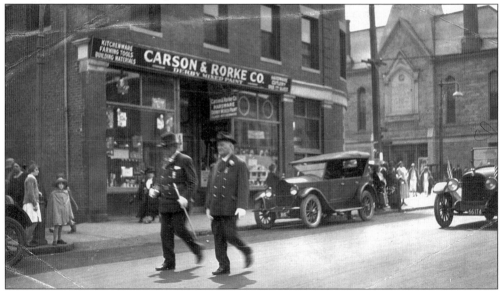

A highlight of Memorial Day 1931 was the participation of the two surviving members of the Charles W. Carroll Post. On the left is Comdr. John E. Bronson and on the right is Westin F. Hutchins. For years, Commander Bronson visited Dedham schools annually to give his rousing accounts of the Civil War to students. He was on the reviewing stand at Dedham's 1936 tercentenary parade.

Robert Rolland Bayard Jr. entered the service on July 25, 1917, and was assigned to Company B, 5th Regiment, MVM. On February 9, 1918, he was the first Dedham man to die in action with the American Expeditionary Force in France. Earlier fatalities were Henry Weston Farnsworth, who died fighting with the French Foreign Legion in October 1915, and John Ruddeman Jr., who died of scarlet fever in January 1918.

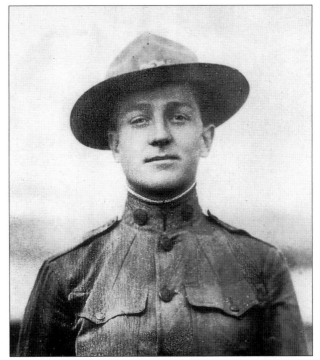

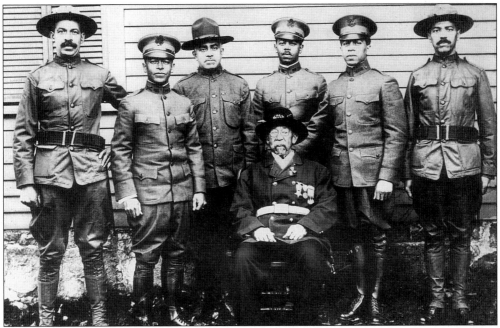

This Dedham family served in three wars. William B. Gould—Civil War veteran, already in his 80s wearing his GAR uniform—is seen here seated. His sons, standing from left to right, are Lawrence Gould and James Edward Gould, both in World War I; James B. Gould Jr., one of 36 men from Dedham in the Spanish-American War and Philippine action; and Herbert Gould, Ernest Gould, and Frederick Gould, who all served in World War I. (Courtesy of William B. Gould IV.)

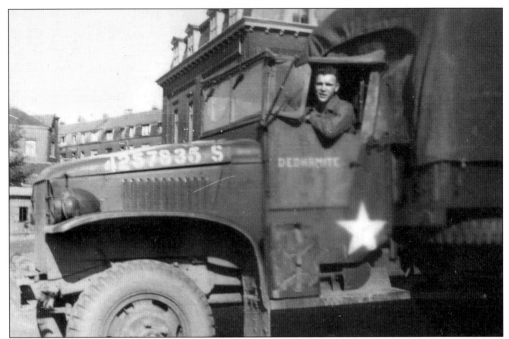

In this view, the truck is lettered "Dedhamite." The location is Germany, and the soldier is Alan Milld of Riverdale, Dedham. More than 2,400 Dedham men and women served in the war, and 72 made the supreme sacrifice, their names being on individual plaques on a memorial at the Dedham Town Hall. Hundreds were decorated for meritorious service. (Courtesy of Charlotte Milld.)

Col. Eliphalet Stone gave this monument and lot to the town's Civil War veterans; it is located in Brookdale Cemetery, which opened in 1878. The year is *c.* 1910 and the flags indicate the photograph was taken around Memorial Day. At the corner of East Street and Eastern Avenue is a memorial to PFC John Barnes III, Dedham's only Medal of Honor winner, who died in Viet-Nam on November 12, 1967.

Eleven
ORGANIZATIONS

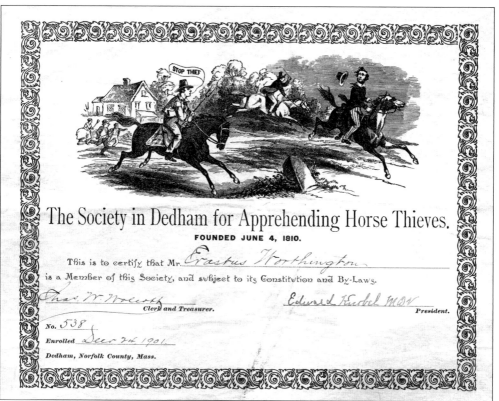

The Society in Dedham for Apprehending Horse Thieves has records dating back to 1810. An assignment to a rider to pursue the horse and thief would name the horse owner and describe the missing horse and the suspected thief. The number of horses regained is not recorded. Surviving documents do list the hotels where members enjoyed the best in dinners. The group still meets for dinner every year on the first Tuesday in December.

Dedham's Masonic roots go back to an 1802 charter for the original Constellation Lodge. Membership declined in the face of anti-Masonic agitation in the early 19th century. Dr. Elisha Thayer was one of three faithful members. He designed this Masonic door knocker for his front door at 618 High Street to testify to his affection and respect for the order.

Charter officers of the Eastern Star pose in 1923. They are from left to right as follows: (front row) Dorothy Clough, Edwin Ricker, Frances G. Spiers, Mary E. Richardson, Gertrude Hague, Walter W. Chambers, and Elsie Moody; (middle row) Elizabeth Stroud, Delia H. Bond, Lucy M. Symonds, R. Maude Henderson, and Robina Hirsch; (back row) Eunice Evans, Margaret Wyman, Adah Wilson, Maude E. Wright, Mollie Phillips, and Emma V. Pettingell.

In 1856, the Norfolk Agricultural Society held its annual fair at the corner of what is now Common and Bridge Streets. Formed in 1849, when farming was a majority occupation, the society's trustees came from towns in the county. Committee members in each town encouraged exhibitors to show bulls, milch cows, horses, and fruit. Trotting horses competed on the half-mile racetrack behind the Exhibit Hall.

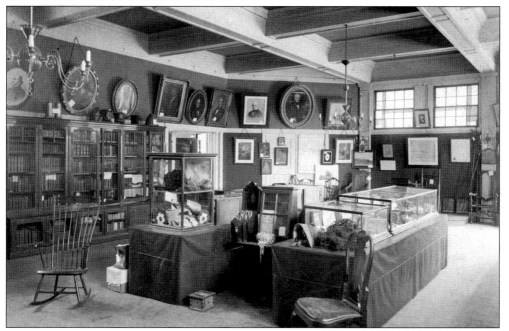

The Dedham Historical Society, founded in 1859, built its headquarters at 612 High Street in 1887 through a bequest from Hannah Shuttleworth, whose home on the site had been Dedham's first post office. This opening-day photograph was taken by Fred Holland Day, considered by many to be the father of modern photography. Many items were loaned, and others may still be seen today in the museum. The library was later moved downstairs.

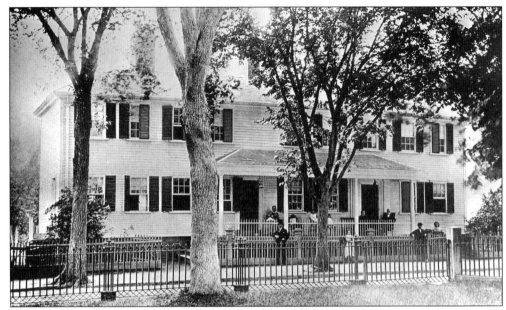

The Baker family home, at 18 Norfolk Street, is now the headquarters of the Family Service of Dedham. In 1880, two Crehore sisters opened their home on Walnut Street to the poor and sick in their neighborhood. With help from friends, they founded this pioneering social services organization.

The Knights of Columbus was organized in Dedham in 1882 as a Catholic service organization. In 1911, the group supported this baseball team. As did so many organizations of that time, this Catholic men's group provided insurance for members, social meetings, and activities. In 1925, the Knights of Columbus dedicated its hall on the second floor of its building at the corner of High and Washington Streets.

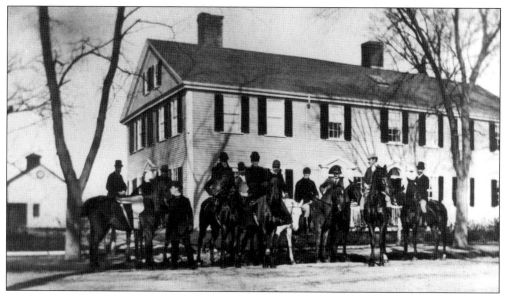

The Dedham Polo Club members, before their clubhouse at 943 High Street, are ready for a ride. They are, from left to right, Dr. H. L. Morse, S.D. Warren, Groom, Mrs. J.W. Elliot, Mrs. S.D. Warren, E.M. Weld, A.R. Weld, Dr. J.W. Elliot, Herbert Maynard, and Dr. A.T. Cabot. In 1910, the Dedham Polo Club and the Norfolk Country Club combined as the Dedham Country & Polo Club, Westfield Street. In 1922, the club completed an 18-hole layout.

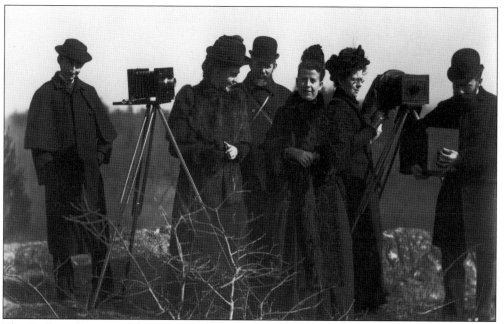

The Dedham Camera Club was intrepid in carting its heavy equipment in the snow. Formed in 1891 under the auspices of the Dedham Historical Society, club members made glass slides of Dedham scenes and also mounted many images on lantern-slides for programs. Members of the club included George Cushing, John Guild, Edward L. Homer, George Humphrey, Robert Rafferty, and Annie Fisher Thayer.

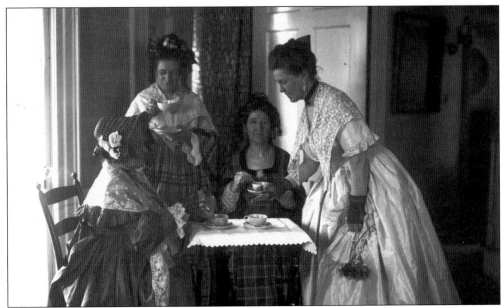

Women of some leisure founded the Afternoon Club in 1887 to promote general intelligence and culture. The club rules called for a maximum of 50 members to meet at members' homes for lectures, discussions, and tea at least once a month from November to May. First-year lectures included "House Sanitation," "Women in Plato's Republic," and "Charlotte Bronte and George Eliot."

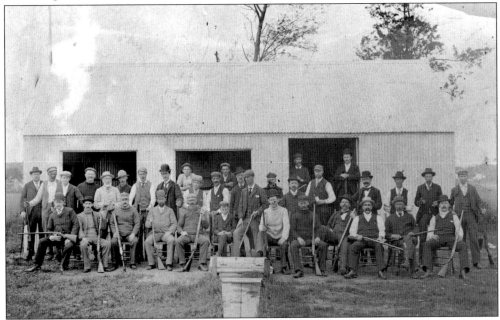

Here are participants at their ease at the Clay Bird Shooting match game between Dedham and Hingham, held in Dedham. When the group started, members held an annual shooting match around Thanksgiving to shoot at poultry at so many paces and so much per shot. For many years, they shot in the meadow below the Mechanics Building, on Washington Street. Named the Dedham Rifle Club, they shot off the Island Road (Bridge Road) until 1874.

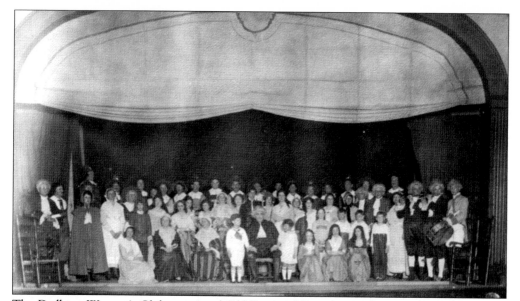

The Dedham Women's Club sponsored *Old Days and Doings in Dedham*, the cast of which is shown filling the stage at Memorial Hall on February 22, 1922. They are costumed for stories of the first town meeting on Dedham soil on March 22, 1637; Lydia Fisher and the Regicides; George Washington visiting Fisher Ames; the Avery Oak and the frigate *Constitution;* and a quilting party of 1807. Charles Mills painted the scenery.

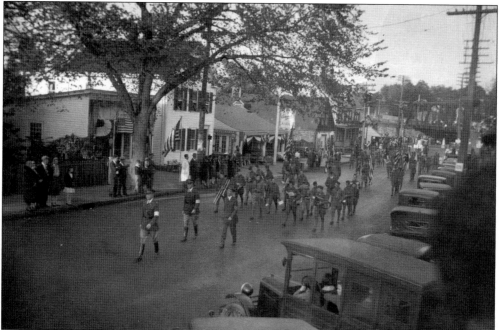

Boy Scouts march here in October 1930 celebrating Dedham history and the tercentenary of the Massachusetts Bay Colony. Boy Scouts began in Dedham in 1918. Notable early leaders were Hans Kudlich, James Noyes, Harry Kubick, John Jenner, Louis Grunner, Newton Kimball, and Robert Sinclair. The Dedham Country Day School and the Church of the Good Shepherd sponsored the first Cub Scout packs.

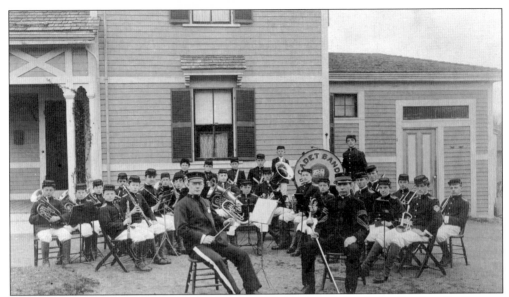

Area bandmasters Fred I. Ayers and Charles Hatch organized the Cadet Band in Dedham in 1907. Their purpose was to keep boys off the streets and to save them from forming the habit of cigarette smoking. Any member found puffing was kicked off the band. The dues were 25¢ a week for two rehearsals. For five years, the band joined parades and even played at a reunion of the Fairbanks family.

Girl Scouts, organized in Dedham in 1919, liked a parade too. The Girls' Candle Club, Girls' Charity Club, and Girls Club of Dedham were unique groups. Camp Fire and 4-H clubs have been other long-lasting young people's groups. In 1988, the Dedham Historical Society's exhibit *Organizing Dedham* listed more than 500 organizations and associations past and present in the Dedham community.

The American Legion organized in Memorial Hall on June 5, 1919. The legion's band poses *c.* 1935 in front of its post at 30 Whiting Avenue. Charles B. Shaw built this house. For some years, it was the Boston Children's Friend Society's orphanage. Henry B. Endicott gave $35,000 to the American Legion to buy the house. It is now Dedham School Department headquarters. The American Legion moved to 155 Eastern Avenue in 1956.

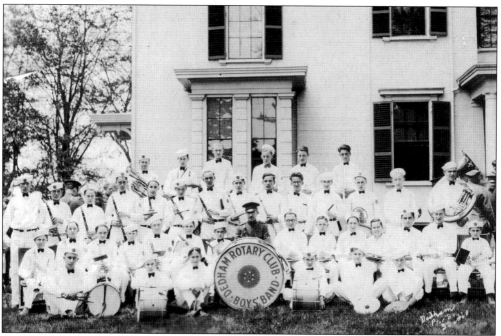

The Dedham Rotary Club of business and professional men was organized in 1923 with 14 members, electing Frank J. Gifford as the club's first president. The Dedham Rotary Club's first townwide project in 1925 raised money to buy uniforms and instruments to form this band. It played for several years at Dedham High School football games, parades, and band concerts.

DEDHAM WOMEN'S EXCHANGE, INC.
50th ANNIVERSARY

Founded
1914

Incorporated
1950

445 WASHINGTON STREET

DEDHAM, MASSACHUSETTS

The Women's Exchange, founded in 1914, is the oldest of the federated exchanges in Massachusetts. It offers women's handcrafted merchandise for sale on consignment. For years, it also operated the Contentment Tea Room. In 1950, Harriet Ohl and six other women incorporated the Women's Exchange "to promote women's welfare, their fellowship and cooperation and their educational, industrial and economic advancement."

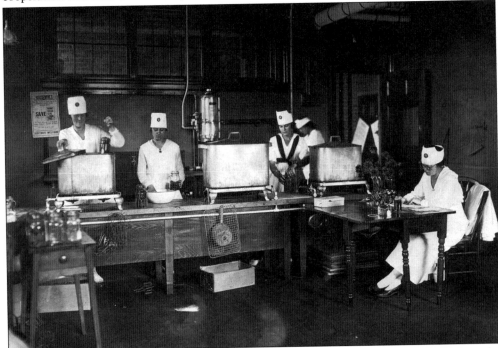

The Dedham Red Cross chapter was organized in 1916. In World War I, volunteers opened a cannery at the Oakdale School, where 68 Dedham High School girls canned 5,236 jars to help 212 families. A 1918 carnival at the Endicott Estate raised funds for the Red Cross to issue each Dedham serviceman a kit with a sweater, a hat, and a "wrister" or "thumber."

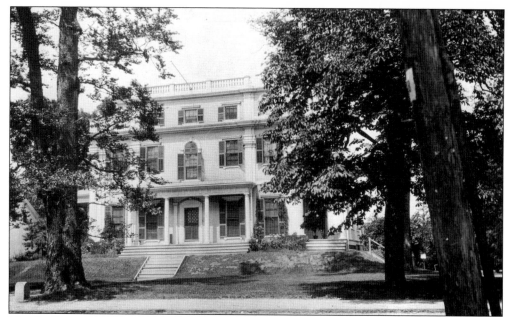

The Dedham Community Association, founded in 1922, has preserved this landmark house at 671 High Street. The house was built in 1795 by Judge Samuel Haven, the first register of probate of Norfolk County and judge of the Court of Common Pleas. Haven House has operated as a community center offering a variety of classes to meet the interests of adults and students and serves as a meeting place for local organizations.

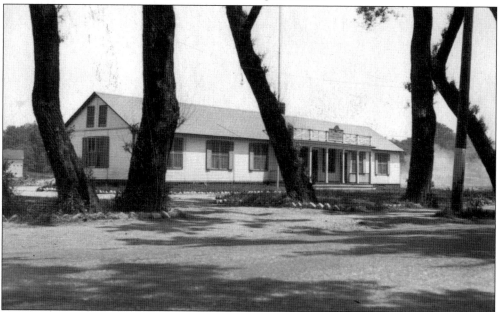

The first home of the John Jacob Jones Post 2017, Veterans of Foreign Wars, on Eastern Avenue had been a temporary building for the Capen School. The post was named for the first U.S. ship sunk in World War I, a destroyer honoring the bravery of Capt. Jacob Jones, who served in the War of 1812 and in operations against Algerian pirates in the Mediterranean Sea. The present home was completed in 1965.

The Dedham Athletic Association sponsored a variety of sports, like basketball, for this team of 1903–1904. The first Grand Meet of the Association was on July 4, 1899, on the Dedham Common at High and Bridge Streets. Runners competed in five races on High Street. Other contests were shot put, high jump, potato race, broad jump, pole vault, and sack race. Also, Dedham had clubs for tennis, badminton, bowling, and baseball.

The Sons of Italy are shown celebrating with song and spirit in 1932. They held annual balls at Moseley's. The Florentine Club was an Italian women's group. There was a German Singing Society and many German ladies' clubs. The Irish Athletic Association was active. The Mill Village Old Home Association was founded c. 1924 and was led for about a quarter century by Owen J. Reynolds, labor crusader.